PHOTOGRAPH WEDDING DETAILS

A Guide to Documenting Jewelry, Cakes, Flowers, Décor, and More

TIFFANY WAYNE

AMHERST MEDIA, INC. ■ BUFFALO, NY

Special Thanks

The wedding day is a collaboration amongst professional creative vendors. While there are many vendors featured in this book, a special thanks goes out to the following: Andy Beach, Elly B Events, Angela's Bridal, Lola Saratoga, Fleurtacious Designs, Jenny C Design, Styled by Melissa, Samantha Nass Floral Design, Deesigns by Dee, STRUT. Spalontique, Mazzone Hospitality, Party with Mia, J.S. Watkins, Lily Saratoga, Chatham Flowers, and Total Events.

Published by:
Amherst Media, Inc.
PO BOX 538
Buffalo, NY 14213
www.AmherstMedia.com

Publisher: Craig Alesse
Senior Editor/Production Manager: Michelle Perkins
Editors: Barbara A. Lynch-Johnt, Beth Alesse
Acquisitions Editor: Harvey Goldstein
Associate Publisher: Kate Neaverth
Editorial Assistance from: Carey A. Miller, Roy Bakos, Jen Sexton, Rebecca Rudell
Business Manager: Adam Richards

ISBN-13: 978-1-68203-104-9
Library of Congress Control Number: 2016938273
Printed in the United States of America
10 9 8 7 6 5 4 3 2 1

AUTHOR A BOOK WITH AMHERST MEDIA!

Are you an accomplished photographer with devoted fans? Consider authoring a book with us and share your quality images and wisdom with your fans. It's a great way to build your business and brand through a high-quality, full-color printed book sold worldwide. Our experienced team makes it easy and rewarding for each book sold—no cost to you. E-mail **submissions@amherstmedia.com** *today!*

www.facebook.com/AmherstMediaInc
www.youtube.com/AmherstMedia
www.twitter.com/AmherstMedia

CONTENTS

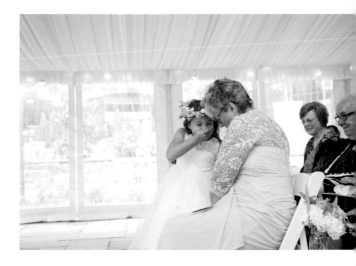

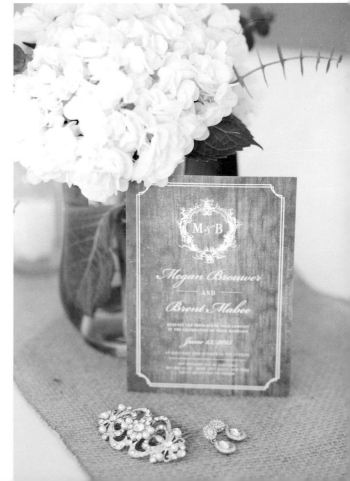

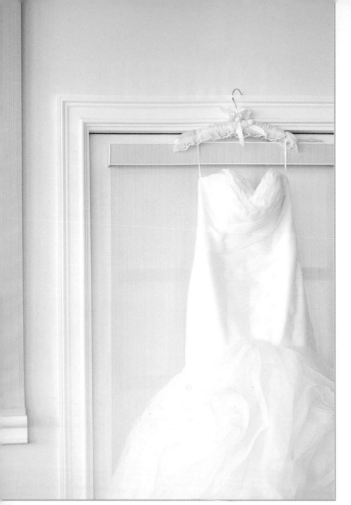

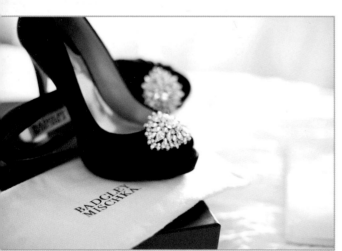

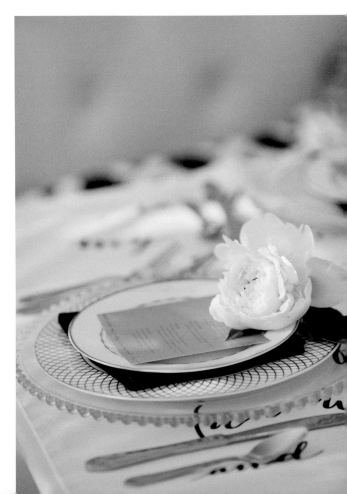

ABOUT THE AUTHOR

Tiffany Wayne is an award-winning photographer and author based in Upstate New York. Her work is published regularly in magazines and popular wedding blogs. Tiffany's client list includes professional athletes and models, on-air personalities, actors, and musicians. She is the recipient of five honorable mentions from the International Lucie Awards, and in 2012 her business was nationally featured in the industry-leading magazine, *Rangefinder*.

In 2014, Tiffany published her first instructional photography book, *Photograph Couples: How to Create Romantic Wedding and Engagement Portraits* (Amherst Media); it is available for purchase worldwide.

Tiffany regularly gives back to her community through charity and education. In 2011, Tiffany Wayne Photography joined forces with Dollars for Scholars and created a scholarship (TWP Creative Excellence Award) for high school students pursuing a career in a creative field. In May 2015, she was chosen to be the Albany, New York leader for the Rising Tide Society, a group of creative entrepreneurs who believe in community over competition. Tiffany has also made guest-speaking appearances at the high school, college, and professional levels.

Prior to opening her photography business in 2010, Tiffany worked in both New York City and Los Angeles holding leading roles in the industry, including Director of Photography for a national women's magazine and senior photo editor for a celebrity agency.

Tiffany is a 2005 graduate from Hallmark Institute of Photography; her portfolio earned her a spot in the top 10 percent of her class. She also holds a Bachelor's degree in Communications and Media from SUNY Cortland. Tiffany frequently travels and is available for assignments worldwide.

INTRODUCTION

Weddings are a beautiful celebration of love that is not only memorable for the couple, but also for family and friends in attendance. Part of what makes these celebrations so memorable is the attention to detail—the effort that the couple puts in to make their surroundings a personal and sentimental space in which they and their

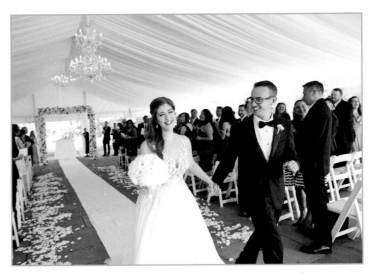

guests can laugh, love, and rejoice as they celebrate the day.

While tying the knot doesn't require personalized details, most couples plan for months—and sometimes even years—to make sure their wedding celebration is the best representation of who they are as individuals and as a couple. In my opinion, the job of the professional wedding photographer should not be limited to photographing the couple. Now, don't get me wrong: the main focus will always be on the couple. However, the details are just as important because, let's face it, the wedding-planning process wouldn't be as tedious if there were no concern for the aesthetics of the day.

When looking through their wedding album, the couple should find a collection of images that show every significant moment and every carefully chosen accessory or visual element that sets the stage for the day.

Even the little things that could easily be forgotten in ten or twenty years should be documented. As wedding photographers, we strive to create better portraits of our clients. Let us take a moment to look beyond the couple and create beautiful images of the elements that set the scene as well.

This book will focus on all things details—the rings, dress, shoes, stationery, food, and even those special quiet moments when no one is watching. In these pages, you will find tips on shooting angles, selective focus, and lens selection. You'll get tips on where to look for reaction shots, and you'll discover ideas for utilizing your environment to best highlight a detail. Whether you're new to the wedding industry or a seasoned pro, there is something in this book for everyone. Take a look, and don't be afraid to look beyond the couple!

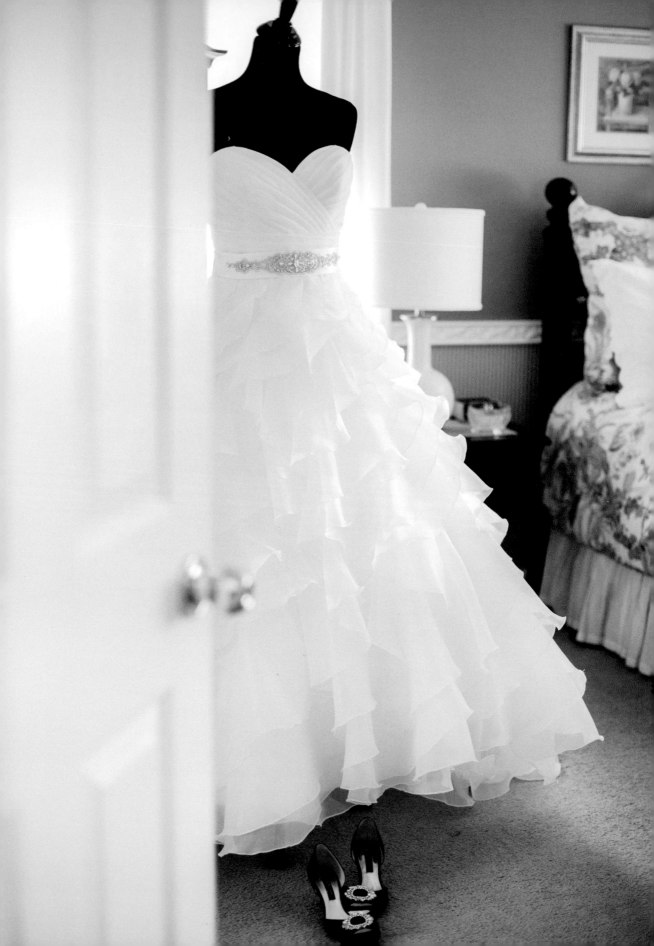

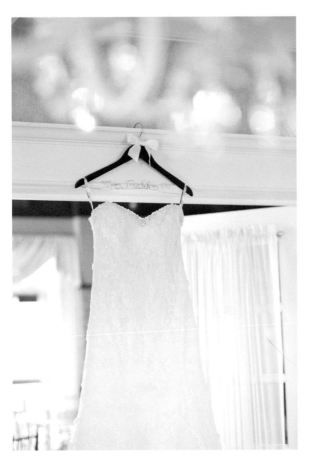

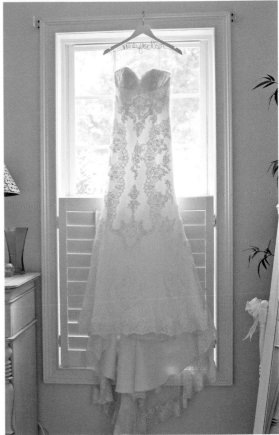

A Sneak Peek *(previous page)*

Open the door partway, shoot past the door, and focus on your subject. Doing this creates a sneak peak feeling when viewers look at the photo.

Beautiful and Bright *(above left)*

Because I enjoy shooting bright, light images, I saw this room as the perfect opportunity to capture an interesting shot of the dress. The carpet was very dark and distracted the eye from the white dress. Once I completed the full-length image, I stood on a step stool and composed the shot with a white chandelier in the foreground. This helped to create the bright feeling I was going for. Challenge yourself to create an image that's different from the standard fare.

Framing the Dress *(above right)*

Hang the wedding dress in front of a window or in the middle of a doorway. This will help to show the way the dress flows when it is not on the bride. I really like the way that the window frames the dress in this image.

♥ *Remember to capture images that show the way the dress flows before the bride puts it on.*

Soft Tones *(left)*

I love a high-key image. Here, the organic shape of the dress is juxtaposed with the geometric architectural elements, which helps draw attention to the subject.

Close Quarters *(right)*

I was limited in terms of the amount of space I had to photograph this bride's wedding dress. It hung on a trifold mirror next to a closet. I wanted to avoid showing the contents of the closet so that the photo would look clean and polished. Across the room, there was a dresser and mirror with some floral décor. By shooting the dress in the mirror through the décor, I was able to produce a beautiful setting with the dress as the focal point.

♥ *Use soft light and minimize distractions to beautifully capture her perfect dress.*

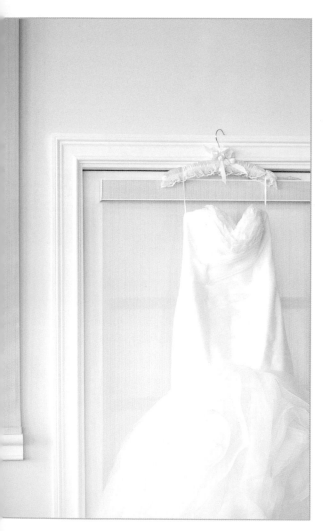

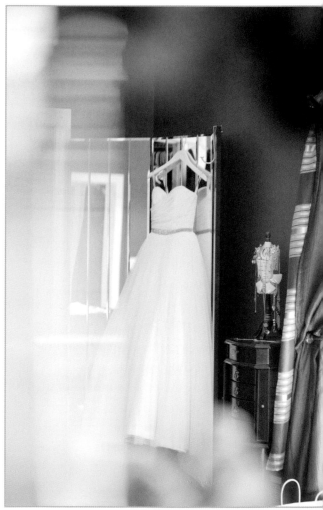

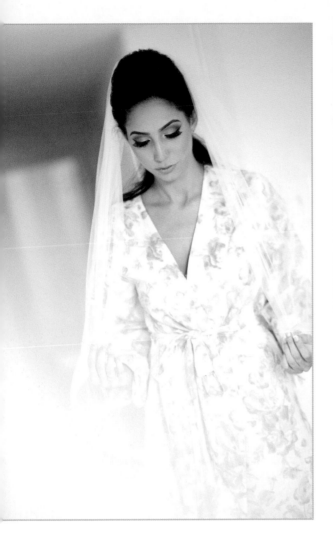

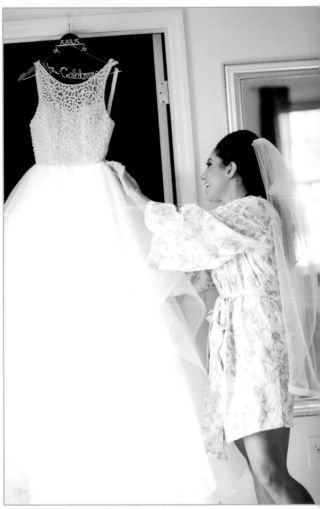

Capture the bride's emotions, from serenity to excitement, as she prepares for her day.

Time to Herself *(left)*

Try to document the bride taking a moment for herself after her hair and makeup are complete. You can add a sense of depth in the image by shooting past some fabric or a bouquet of flowers.

The Moment She's Waited For *(right)*

Photograph the bride as she begins to take her dress off of the hanger to put it on. Her excitement will make for an emotion-filled photograph that will help you to tell the story of the day.

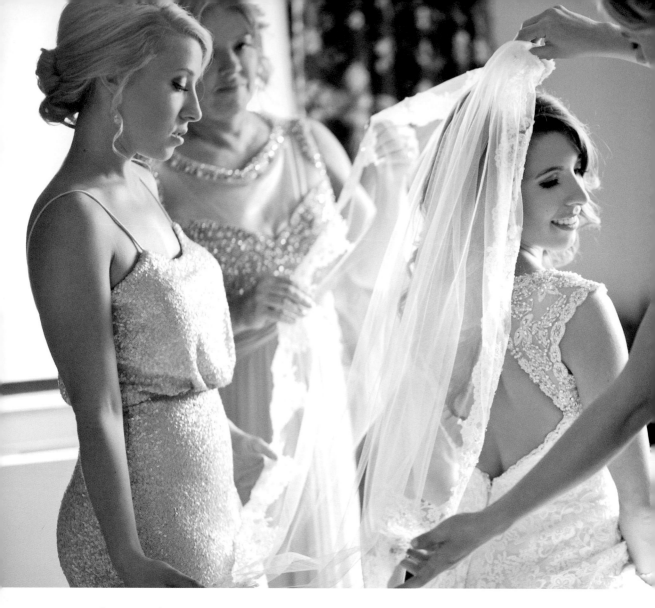

Placing the Veil *(above)*

My favorite moment of the bride getting ready is the time when she puts on her veil, and I particularly love to capture the movement. She is usually surrounded by the people who mean the most to her, and their reactions and expressions are priceless. This is also the moment where the bride's feelings shift from surreal to real.

For this image, I had the bride sit on the edge of the hotel room bed facing a large window. I wanted to get some light that would highlight her hair and face as she turned to look over her shoulder.

The Finer Points *(following page, top)*

Photograph the dress from a side angle and a wide aperture to ensure a shallow depth of field. Beading, belts, lace, and ruffles are beautiful when shot with a low f/stop.

Capturing Texture *(following page, bottom)*

Shooting textures with a shallow depth of field will create great depth in your image. Fabrics such as the bride's veil or a bridesmaid's dress also make a perfect background when photographing the bride's jewelry and other accessories.

Images that show movement help to tell the story of the day.

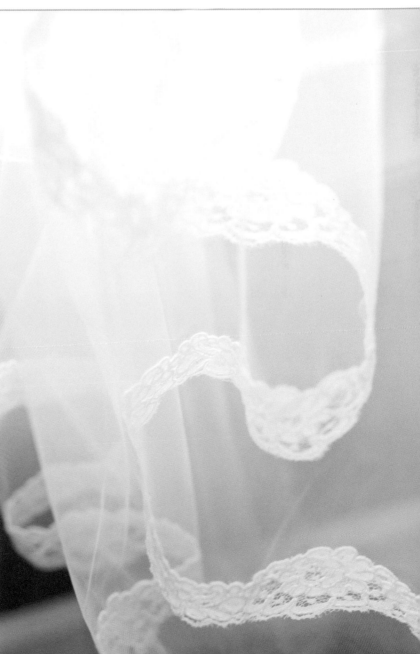

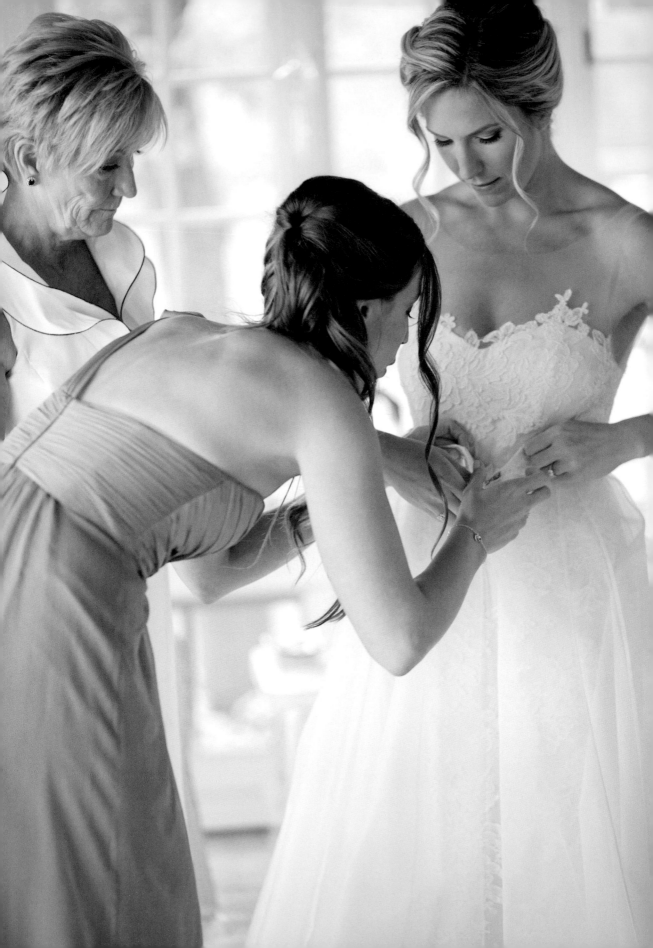

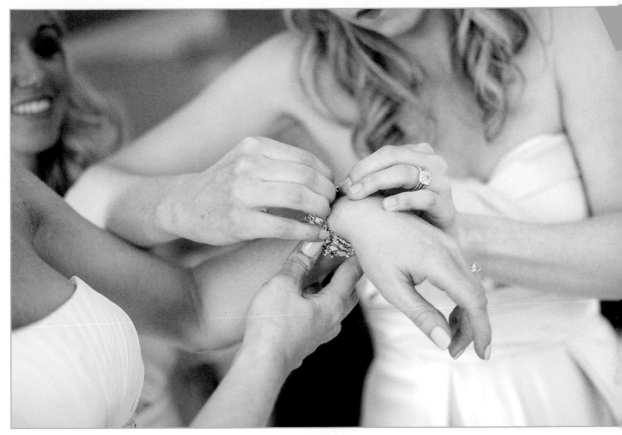

Helping Hands

(previous page) Moments like this will be cherished for years to come. Be sure to document the mother of the bride or a bridesmaid helping the bride get ready any chance you get.

(above) Bridesmaids are there to help the day run smoothly for the bride. Photograph special moments such as a bridesmaid helping the bride put on her bracelet for priceless images.

Bracelet Detail *(right)*

Using the bride as the background, shoot her adjusting her bracelet(s). This will allow you to use her dress as the background while focusing on her jewelry.

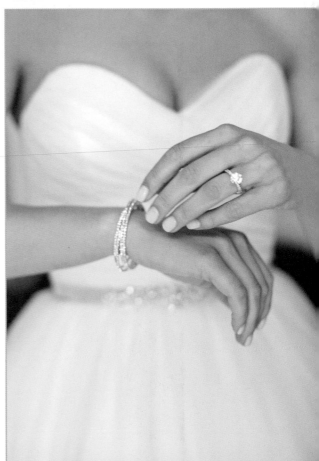

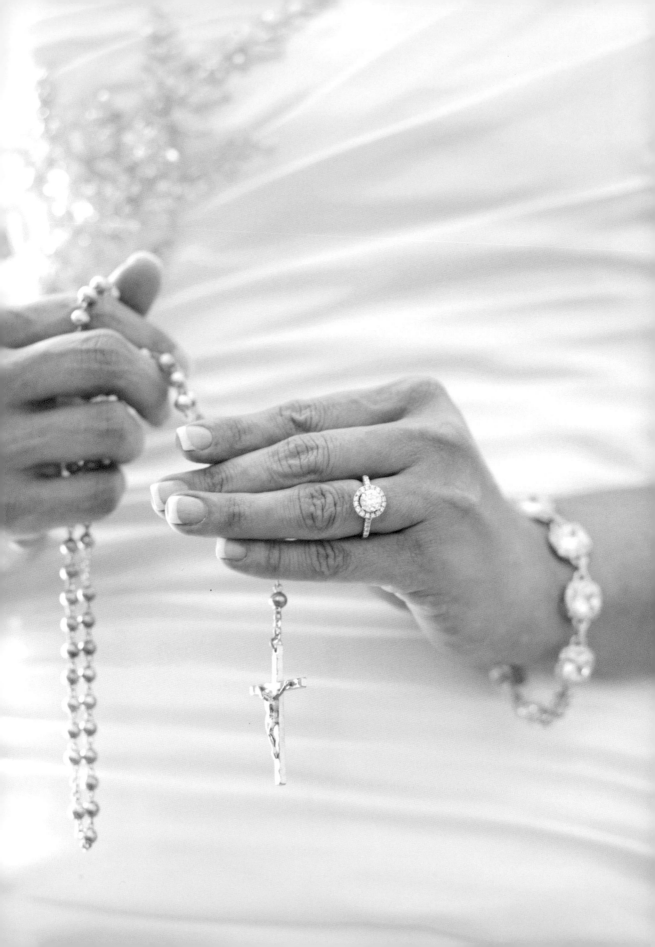

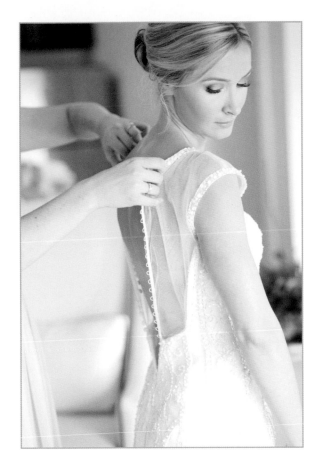

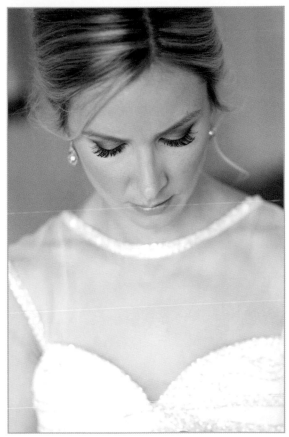

Body Language *(previous page)*

I find myself very aware of my surroundings and the emotions of those around me on the wedding day. This bride held on to a rosary—something that is very personal. It was moments before she left to go to the church, and her nervousness shows in her hands. Photo details like this help to document the emotions of the day.

A Perfect Pose *(above left)*

As the bride's dress is being zipped or buttoned, ask her to turn her head to look down and behind her. This is a serene moment that shows that she is nearly ready for her big day.

Close-Ups *(above right)*

Shoot a close-up of the bride's face while she is looking down at her dress. By cropping in close, you will create an intimate, editorial photograph.

Cropping close can help to create an intimate, editorial feeling in your photographs.

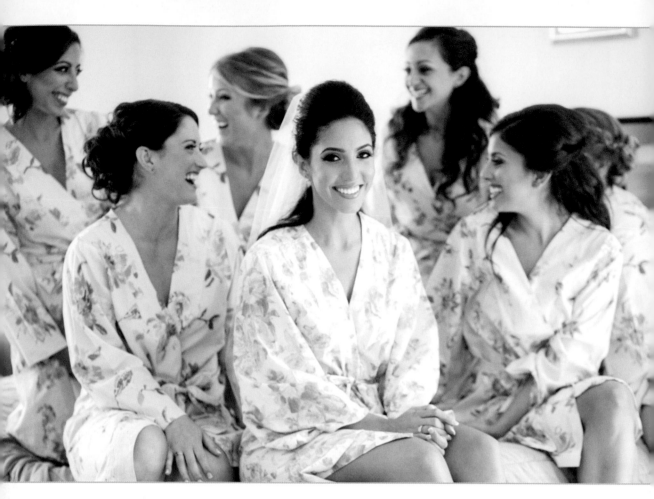

An Intimate Group Portrait

Make it a point to capture a portrait of the bride with all of her bridesmaids gathered around her and showing their excitement for the big day. Have the bride sit slightly closer to the camera than the bridesmaids, then shoot using a wide aperture. This will throw the girls out of focus and make the bride the center of the attention in the image. Also, when photographing a group, pay close attention the head heights of the subjects. Be sure that no two heads are on the same level; this will help to provide a sense of rhythm and interest in the portrait.

Here, beautiful window light from camera left and the soft tones in the women's robes lent a feminine, cohesive look that celebrates the bond they share.

Create a relaxed image of the bride and bridesmaids before everyone has dressed for the event.

The Eyelashes (top)

As the bride looks down and to the side, choose a low f/stop and focus on her eyelashes. Doing so will throw everything else in the image out of focus.

I captured this image with my Canon EOS Mark II camera and 50mm f/1.2 lens. My exposure was f/2.5 at $\frac{1}{200}$ second and ISO 400. The image was made using only window light.

In this case, I chose to convert the image to black & white. The result is an image with a distinctive editorial/lifestyle feel.

In the Moment (bottom)

Here, I wanted to focus on the bride's mother's hands. I believe that including hands in a photograph helps to tell a great story—especially when it comes to a mother and daughter. Once you've focused on the dress details, examine what's happening around the buttons and zipper—a great story lies in wait. Photograph action shots from a side view with a low f/stop to create a sense of movement that places the viewer right in the moment.

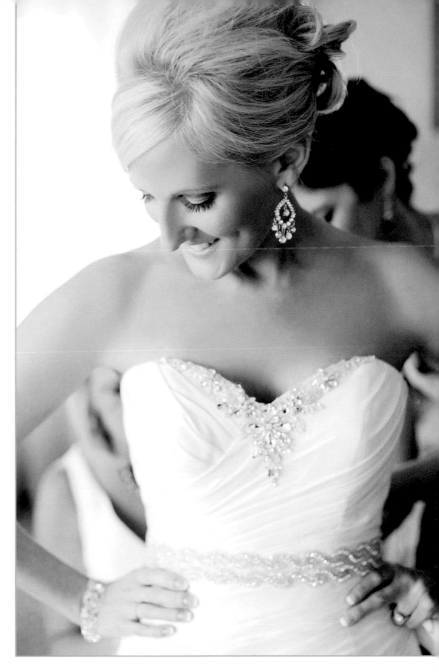

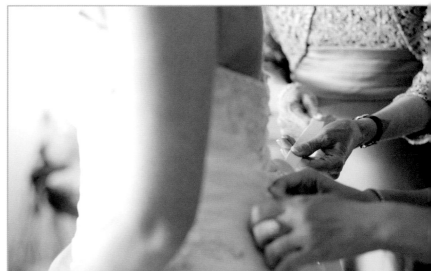

Photograph the Hands *(top)*

Here is another case in which including hands in the image helped to tell a story. In this scenario, the bride's twin sister held her veil as the bride prepared to step into her gown. By cropping into the frame, I was able to amplify the emotion behind the beautiful, authentic moment.

An Intimate Look *(bottom)*

The moment when a bride steps into her gown is very special. Try to capture movement, and shoot from the side. Making these choices will help viewers feel that they are part of the moment. Shoot from a low angle to produce a feeling of depth in the photograph.

A Photojournalistic Approach *(following page)*

For this image, I wanted to focus on the bride's hair rather than the dress detail—even though the bride's mom is clearly involved in helping the bride with her attire. Don't be afraid to capture details at times like this. Doing so creates a natural, photojournalistic depiction of memorable moments on the wedding day.

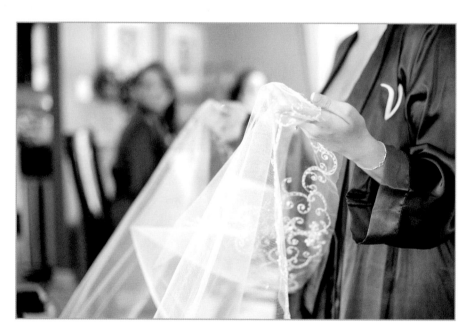

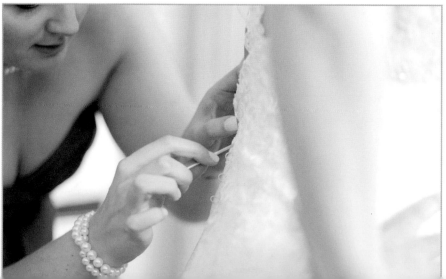

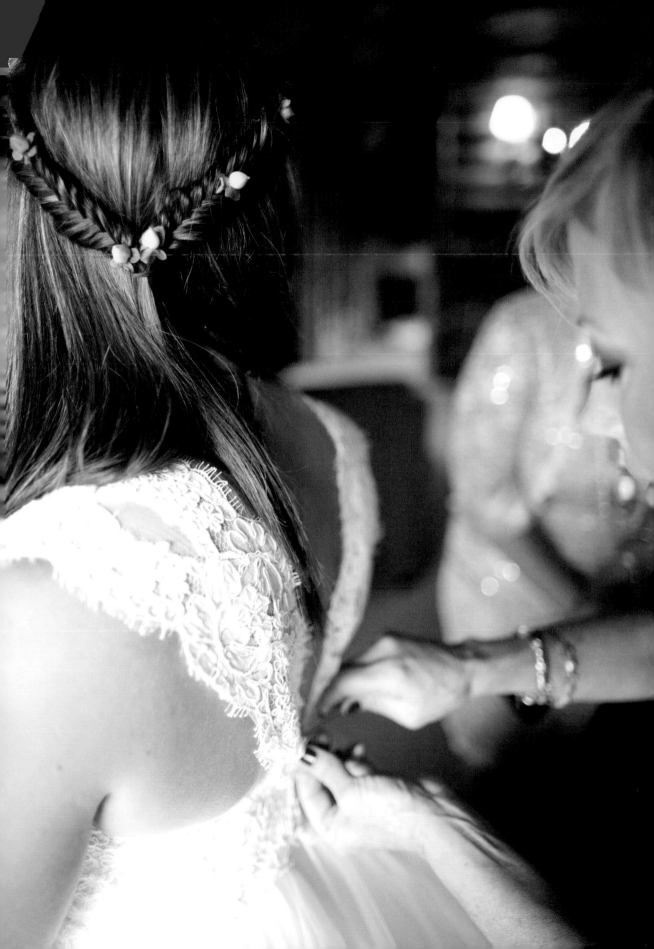

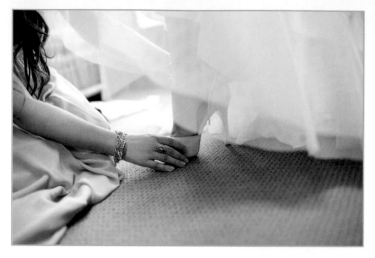

Fairytale Photo *(top)*

This image reminds me of Cinderella! Including other people, even just a hand, adds a lot of life to a photo. This scene was backlit by a large window. I love that you can see the arch of the bride's foot through her veil. You can sense movement; it's something that brings the photo to life.

Buttoned Up *(center)*

Working from a low side angle, focus on the buttoning of the bride's dress while shooting past a member of the bridal party.

Take Action *(bottom)*

From a low angle, shoot the fluffing of the bride's dress. Capture movement within the image.

Makeup and More

(following page)

This image was meant to highlight two things: the bride's flawless makeup and her handmade birdcage headpiece. Because the bride was tall, I asked her to sit in a chair with her head tipped slightly downward so I could get a great view of the detail in headpiece. I set my exposure compensation to $+ \frac{1}{3}$ so that her skin tone would look bright and fresh.

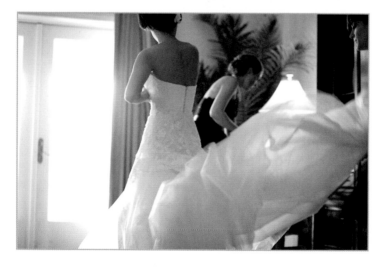

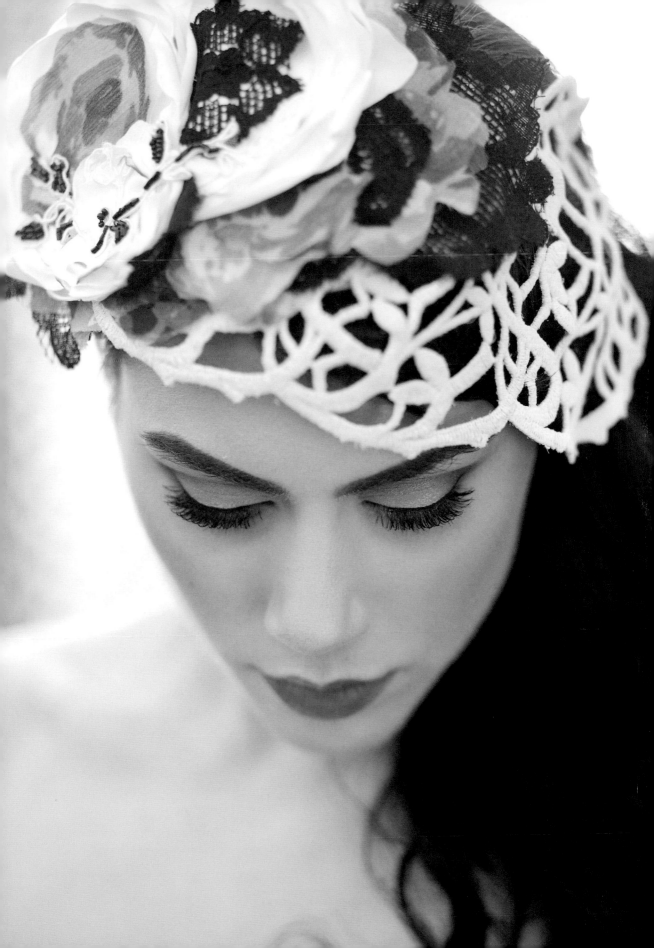

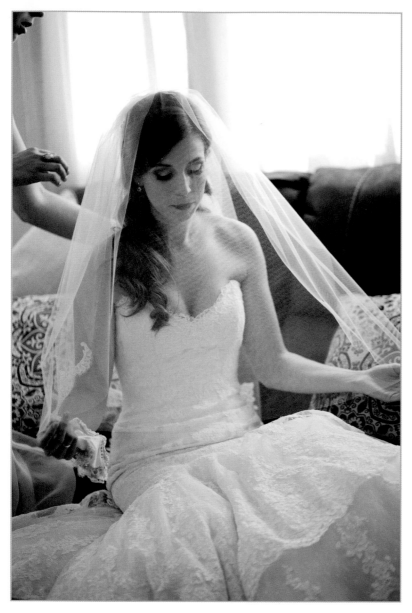

Show the Setting (top)

Capturing some of the detail of the location in which your subject is preparing for her big day is important to creating a chronicle of the wedding. Photographing from a low angle while the bride is seated will help you to encompass more of the scene within the image frame.

Diamonds
(bottom)

Here, I used a wide aperture to attain sharp focus on the bride's engagement ring. It is clearly the star of the image. The veil and the beautiful bride's profile fall softly out of focus to serve as a secondary subject.

Shaping the Story
(following page)

Using a wide aperture to photograph an individual while shooting past another person can create a feeling of intimacy in an image. This bride had just finished getting dressed, and I loved her mother's expression and body language as she gazed at her daughter.

I shot this image with my 85mm f/1.8 lens. My exposure was f/1.8, $^1/_{100}$ second, and ISO 800.

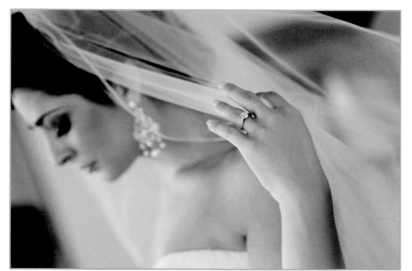

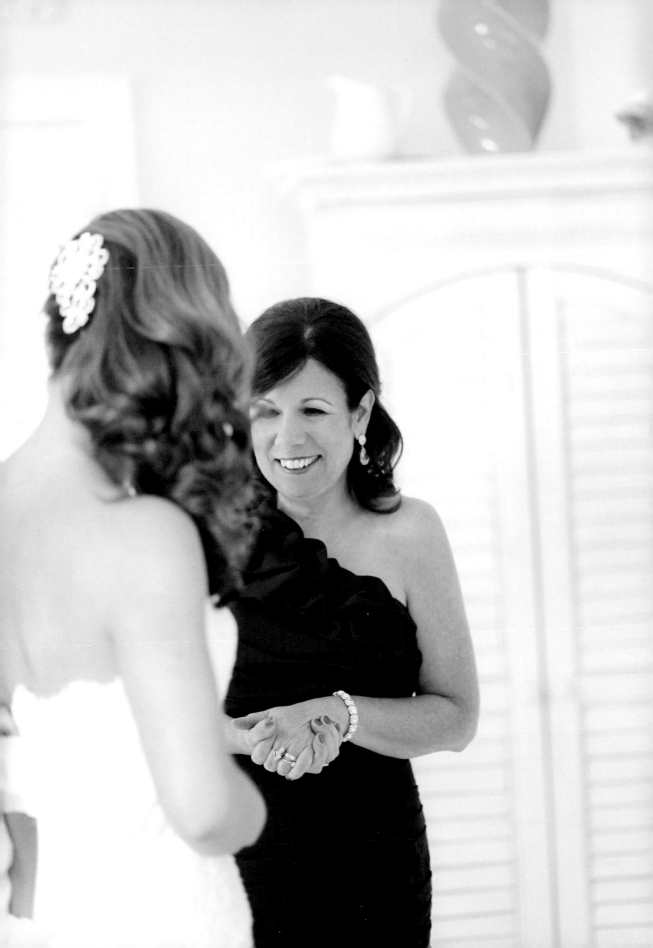

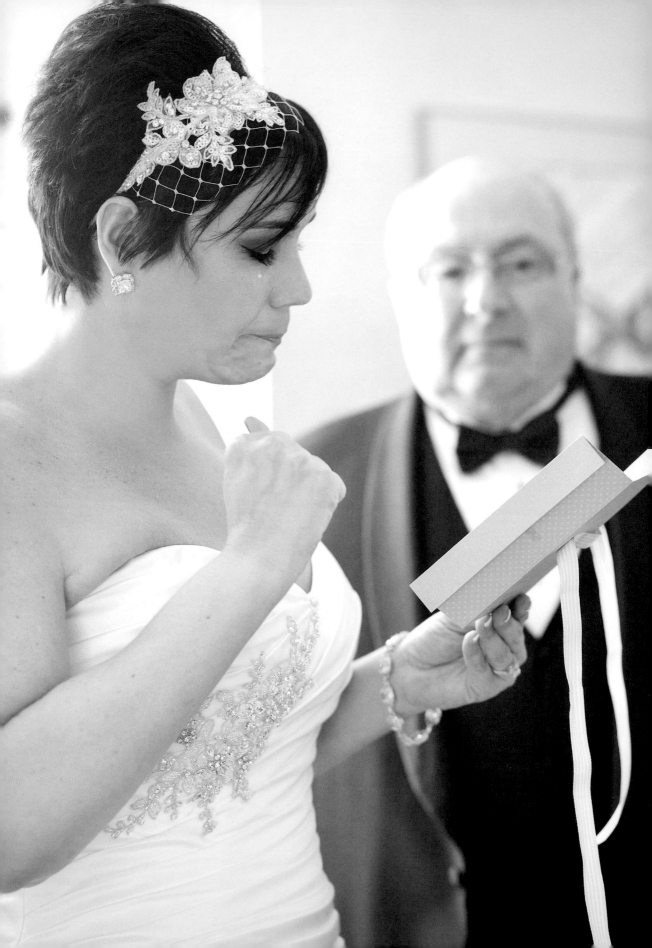

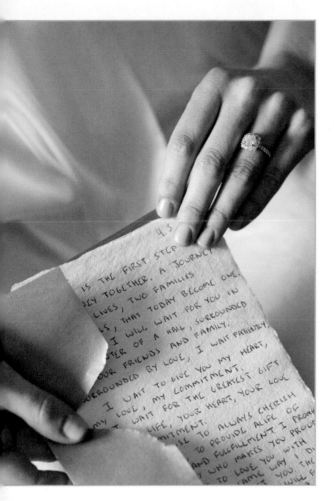

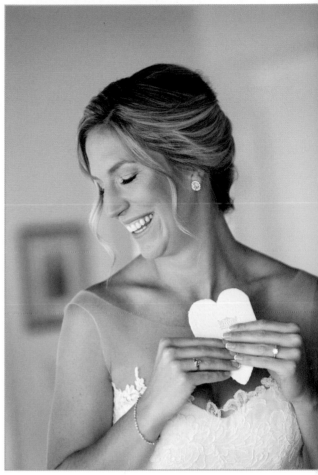

Pure Emotion *(previous page)*

Reactions to special moments are a great detail to photograph with a shallow depth of field. This bride was reading a card from her father, and I loved that he was standing off to the side watching her. A great story can be told with one powerful image.

Love Notes *(above left)*

Intimate gifts and letters are better photographed when held in the bride's hands. Make sure that her engagement ring hand is on top! Images like these are a visual record of the special moments on the wedding day.

In the Shape of a Heart *(above right)*

I loved how this groom wrote a note to his beloved on a cut-out heart. After the bride read the touching note, she was filled with emotion. I asked her to hold the card up to her chest as if she were giving her husband-to-be a hug. Her smile, with her head turned to the side, lent an organic look and feel to the image.

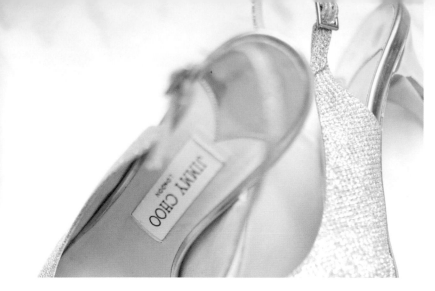

Elegant by Design *(top)*

When photographing a luxury brand-name shoe, highlighting them in a minimalistic setting is idyllic. This way, the shoe will not compete with any other elements in the photo.

Ribbons *(bottom)*

The detail of the back of the shoes is just as important as the front.

I placed these heels on a dresser in front of a mirror. Using my 85mm f/1.8 lens, I dialed in an exposure of f/2.5, $\frac{1}{200}$ second, and ISO 1000. Due to the shallow depth of field and low angle, the pretty ribbons steal the show, but the viewer is able to see a hint of the surroundings as well.

A Neutral Backdrop

(following page)

When photographing shoes with an interesting pattern, it's best to find a neutral backdrop so that the design of the shoe can pop off the background. This image was shot with a Canon 5D Mark III and a 50mm f/1.2 lens.

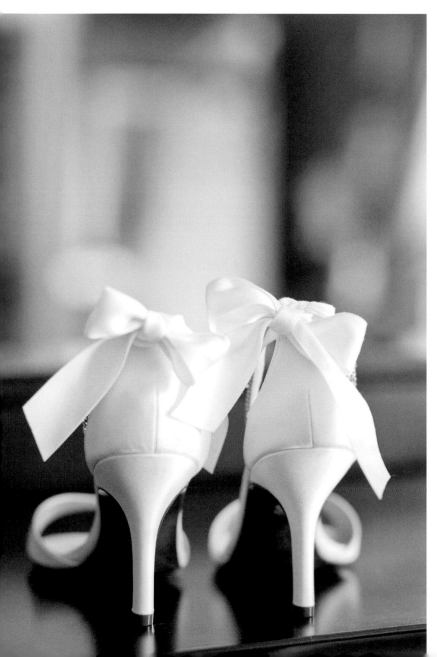

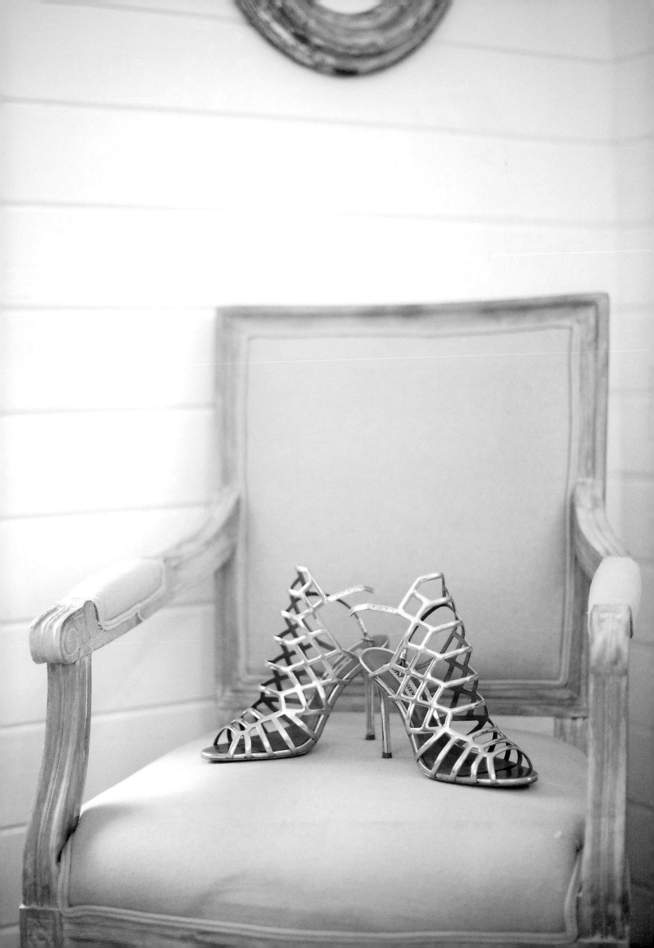

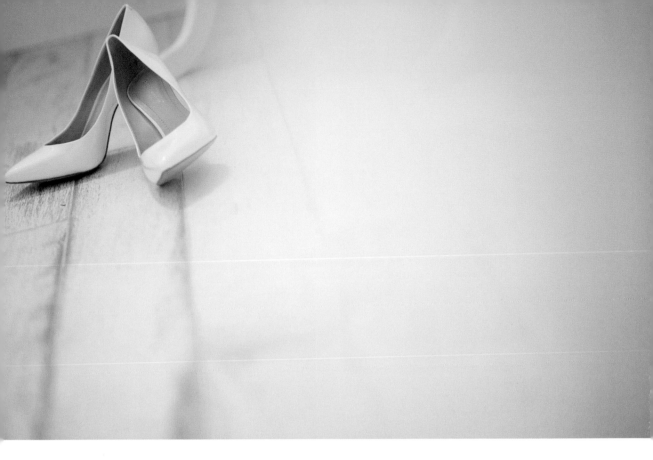

Light and Airy *(previous page, top)*

I adore this image. Shooting on a simple surface with a clean background will create a light and airy feeling in the photograph.

I shot this image with my 85mm f/1.8 lens. The exposure was f/2.5, $\frac{1}{160}$ second, and ISO 1000.

It's in the Details *(previous page, bottom)*

These shoes had such a great design. I wanted to show off the top of the shoe, since that was the most interesting part! Keep in mind that not all parts of your subject must be in the frame. Crop some images in tight for added variety and interest.

I used my 85mm f/1.8 lens to capture this shot. My exposure was f/2.5, $\frac{1}{125}$ second, and ISO 800.

Creative Coverup *(above)*

As easy way to create a clean image is to shoot with material or other objects in the foreground. To obscure some of the details in this room, I simply placed some material in front of my lens. In doing so, I was able to simplify the composition and make it more aesthetically pleasing.

When using this approach, be sure to shoot at f/2.2 or lower to sufficiently blur the object that you are shooting through.

♥ *Shooting through fabric or other objects in the room with a wide aperture can simplify the shot.*

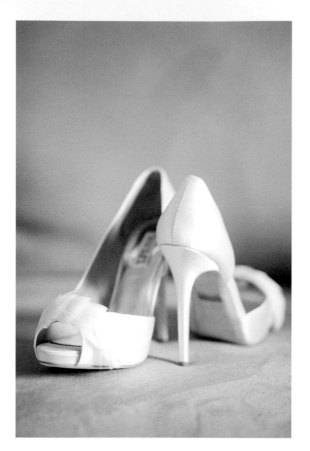

Two Views *(left)*

I loved two things about these shoes: the feather detail and the super-high heel! I wanted to capture both of these features in the frame. By positioning one shoe facing forward and one facing backward, I was able to simultaneously show off both details.

Attention-Getting Detail *(right)*

The bride's shoes are a detail you want to be certain to capture. This pair had some lovely detail on the top that I wanted to showcase. Shooting from above will allow the subject to be seen it its entirety. Using a shallow depth of field will draw the attention to the desired area of the image.

Elegance Meets Function *(following page)*

I prefer a clean, bright image. This bride was not wearing your typical high-heeled shoe on her wedding day; however, I wanted to create an elegant vibe when photographing her boots! I placed them on the white linens in one of the guest bedrooms to create a clean and bright backdrop.

My exposure for this natural-light image was f/2, $^1/_{100}$ second, and ISO 1250.

Pay careful attention to the personal style of your clients and capture images that will appeal to their unique aesthetic.

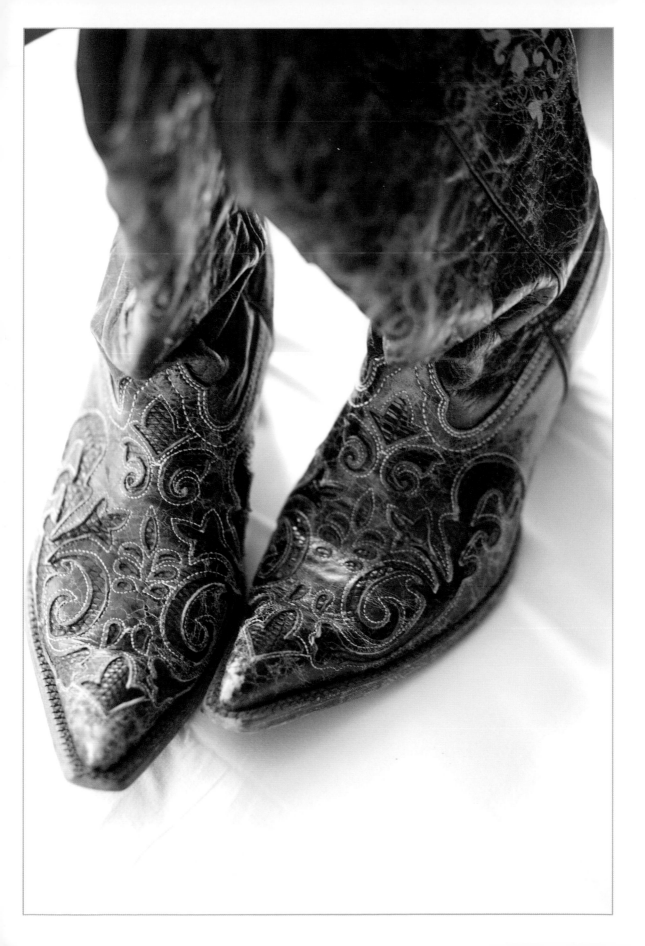

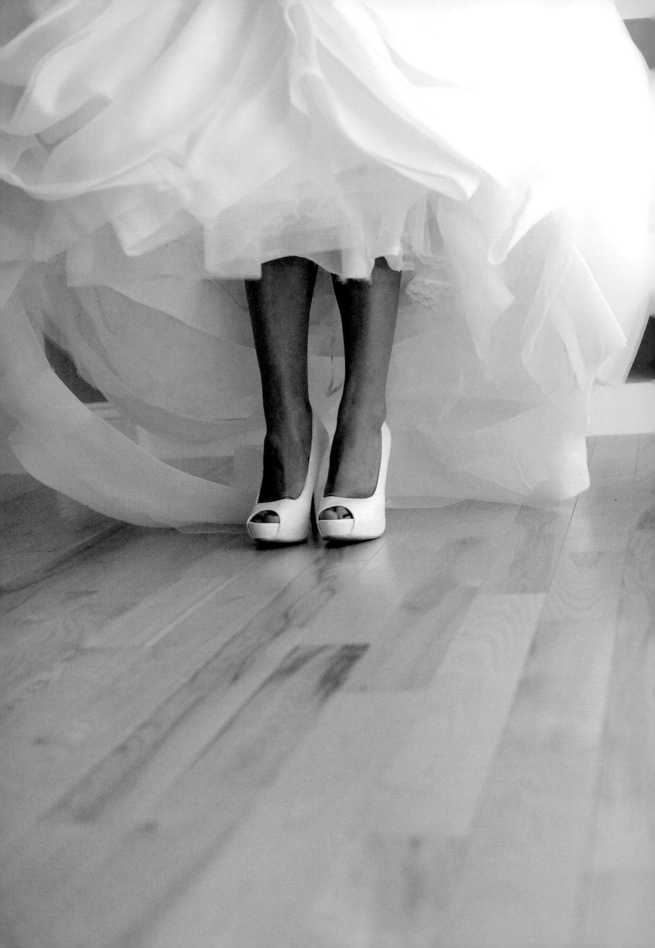

Low Angle, Wide Aperture *(previous page)*

I loved the skirt on this Vera Wang gown. As I watched the bride fluff the ruffles, I realized that the action would make for a great shot. We don't view the world lying on the ground, so a very low angle sparks our interest. In this image, I focused on the shoes using a wide aperture. As a result, the other image elements are not distracting.

Added Attraction *(top)*

From a low angle, place an object in front of your subject and shoot with a shallow depth of field. Here, the bracelet is the primary point of focus, and the shoes serve as a secondary subject.

Brand Conscious *(bottom)*

Shoes are an important detail to capture on the wedding day. If the shoe box is available, consider staging the shoes on it. Focus on the logo and use a shallow depth of field for a beautiful result.

I captured this image with my 50mm f/1.4 lens. The exposure was f/2, $^1/_{80}$ second, and ISO 1000.

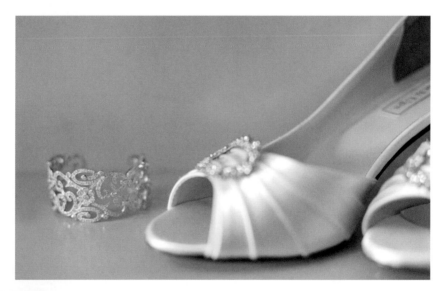

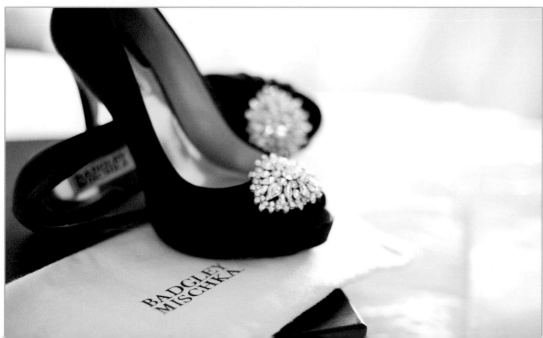

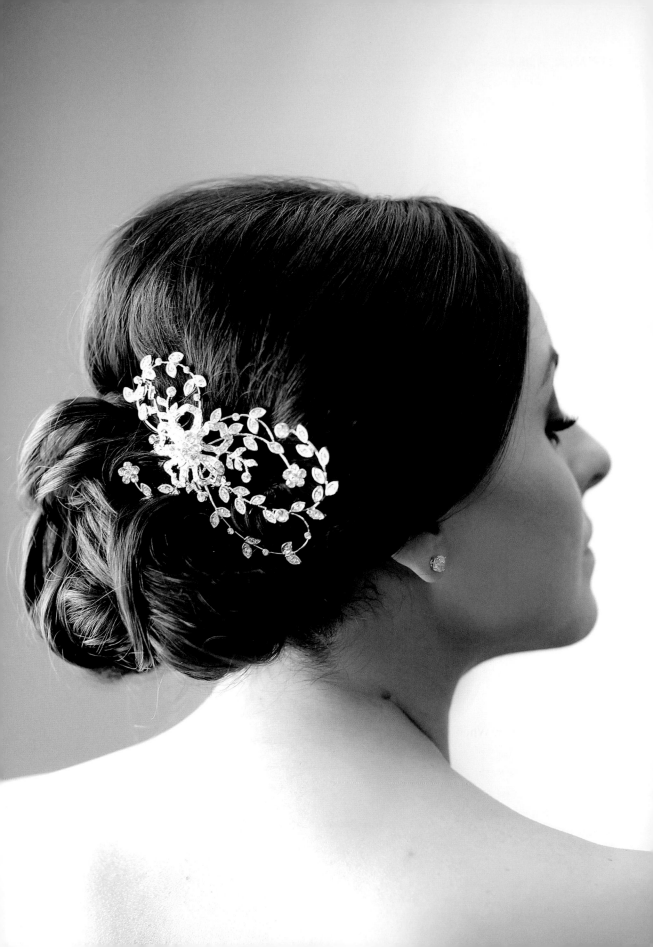

Finishing Touches
(previous page)

In this image, I wanted to focus not only on the bride's hairstyle, but also her beautiful hair clip. The bride was getting ready in a hotel room. I posed her facing a blank wall near a window. I love that her bare shoulders help to keep the eye on the subject.

Storybook Ending *(top)*

With each detail image you capture, you want to tell a story. The room in which this image was made was filled with artificial lighting. In order to create a soft, romantic vibe, I moved a chair close to a window and used a little exposure compensation to produce a brighter image. By shooting from a low angle, I was able to focus on the bracelet and earrings in the foreground.

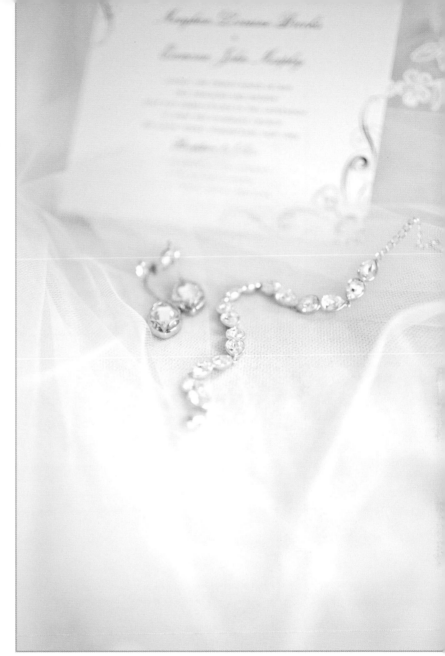

All that Glitters *(bottom)*

A style-conscious bride will appreciate a nod to her accessory's designer. When you set up your shot, place the subject on the same plane as the logo or wording on the product's packaging. When you focus on the subject, the text should appear in focus too.

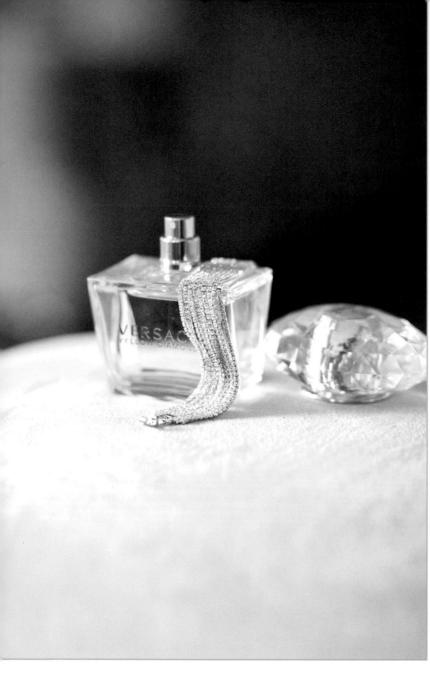

Perfume Plus *(top)*

I love shooting perfume! Doll up the set by incorporating some of the bride's jewelry. Be sure to shoot on a solid surface because the writing on the perfume bottle can sometimes be difficult to read with a busy background.

In this image, the beautifully blurred background and upholstered furniture on which the subjects were staged harmonize with the subject and provide added interest without distracting from the focal point.

Twice as Nice *(bottom)*

The simple beauty of an elegant bottle of perfume is great to photograph, but why stop there? You can add interest in the background by placing another detail behind the bottle.

Here, I focused on the perfume and shot with an aperture of f/2.5. As a result, everything behind the subject fell softly out of focus. The tonal harmony throughout the image helps to produce a clean, uncluttered look. The negative space on the left of the frame directs the eye to the details.

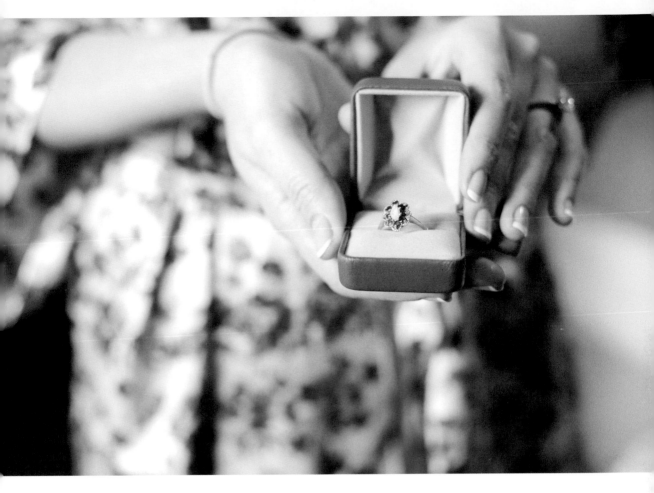

Heirlooms

Weddings are filled with symbolic elements. Often, brides will choose to wear a piece of jewelry that was once worn by a relative, or may perhaps incorporate a personal item like a grandmother's lacy handkerchief as she dresses for the day. Consult with the bride prior to the wedding day to determine whether any such meaningful items will play a part in her day.

Photographs of objects that are being passed on from one person to the next are more meaningful when someone is holding the object. From a low angle, photograph the object in the hands of the owner and include the person as the background of the image.

I captured this image with my 50mm f/1.4 lens. The exposure was f/2.8, $^1/_{125}$ second, and ISO 1000.

Vintage jewelry and other items belonging to loved ones often have great emotional significance.

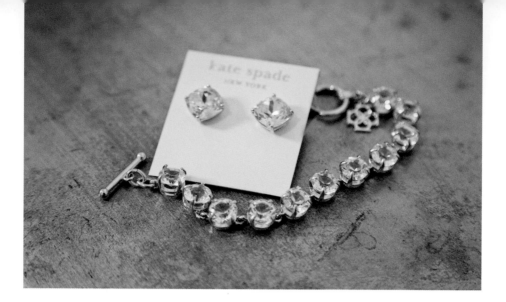

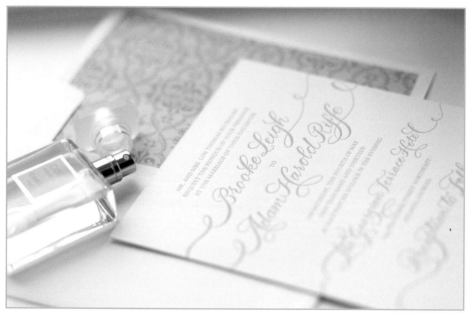

A Bit of Texture *(top)*

Using a simplistic texture as a background will help the subject stand out. Give the image a cohesive look by incorporating a background that is similar in tone to the subject.

A 45 Degree Angle *(bottom)*

Want to create an image with an editorial flair? Lay out the wedding invitation with the bride's perfume bottle, as if it has just been used, then shoot from a 45 degree angle using a wide aperture.

Simplify the Shot
(following page)

Photos that contain multiple elements appear busy. Using a shallow depth of field will help to simplify the image and create a clean, pleasing look that's easy on the eyes.

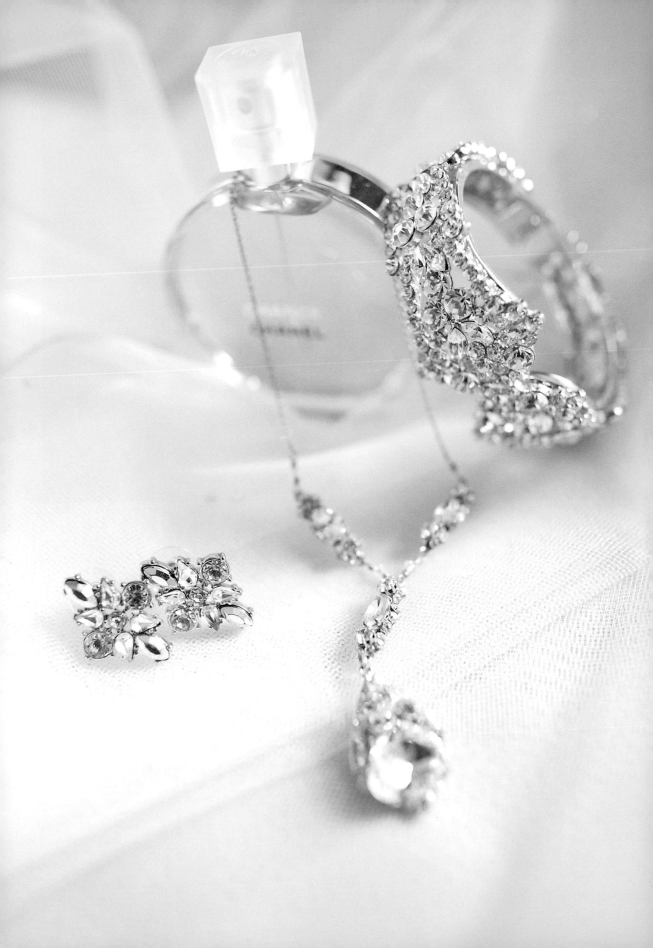

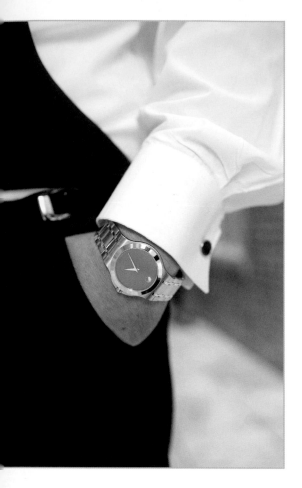
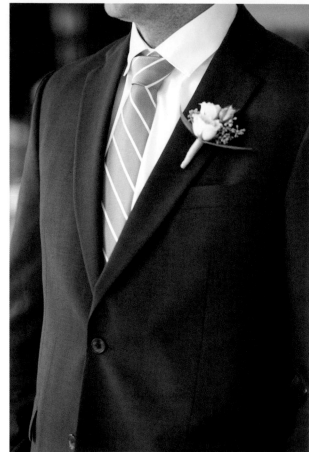

His Accessories *(left)*

The groom's accessories are just as important as the bride's. By having the groom place his hand in his pocket, you will be able to see his cuff links, if he has them, along with his watch. The added bonus? Showing the placement of the hands on a watch will help to create a narrative of the day. For a shot like this, use a shallow depth of field to ensure the viewer's eye is drawn right to the watch.

The Tux *(right)*

The groom's attire is just as important as the bride's, and photographing it is a must. However, it's tough to capture the essence of a suit while it is on a hanger. It doesn't photograph as well as a dress does. Your best bet is to crop in tight while photographing the groom; you will get an appealing shot that documents his attire.

 Crop in close to show the details in the groom's attire and accessories.

In Memoriam *(top)*

Remembering those who have passed on is natural during such a special occasion. For this photo, I asked the father of the bride to hold on to a framed portrait of his parents on their wedding day while standing next to his daughter. The request prompted an organic reaction that shows the subjects' love for dear family members who couldn't be with them on the wedding day.

Something Old, New, Borrowed, and Blue *(bottom)*

The bride gave me some objects to photograph that were a combination of something old and something new. I was drawn to the texture of the quilt on the bed. By staging the elements on top of the quilt, I was able to create a visual story that speaks to the adage "Something old, something new, something borrowed, something blue." I used a shallow depth of field to draw the eye to the initials of the bride and groom.

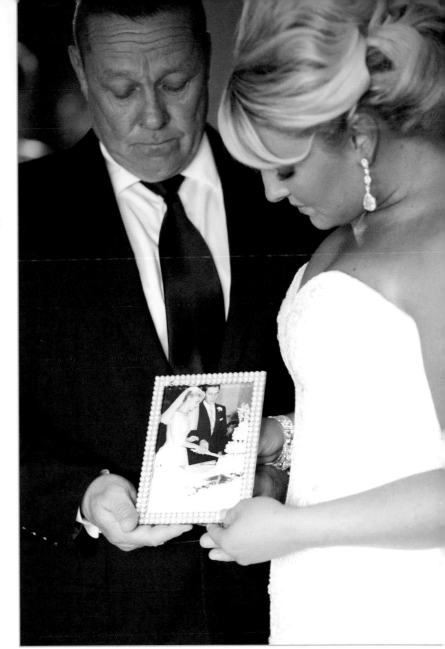

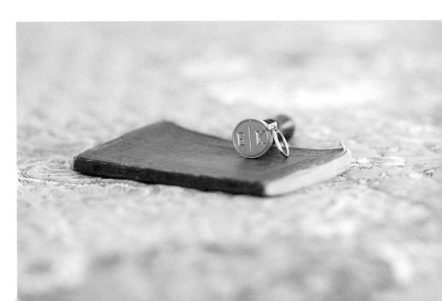

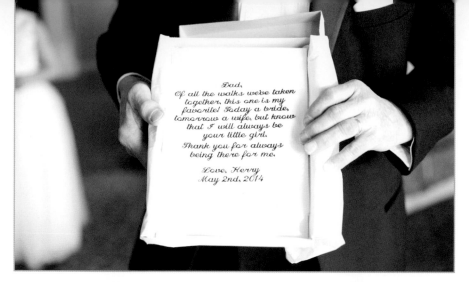

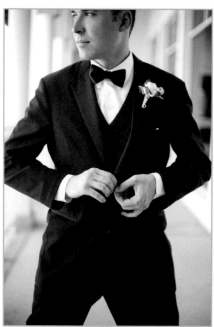

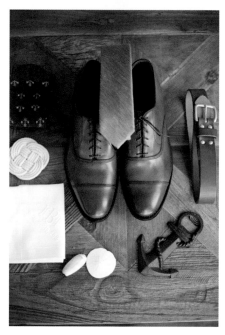

For You, Dad *(top)*

Many times, a bride gives her father a special gift on the wedding day. As this gift contained written words, I wanted to highlight them. I asked the dad to point the gift toward the camera and included his hands in the frame for added impact.

Document His Preparations *(bottom left)*

As the groom buttons his suit, ask him to look to the side. You'll capture a getting-ready action shot that his soon-to-be-bride is sure to love!

The Groom's Details *(bottom right)*

Display the groom's details in an organized fashion and photograph them at f/4 or f/5.6 to ensure everything in the frame is in focus. Don't forget to photograph the groomsmen's gifts, too!

Build on the Story *(following page)*

I loved seeing the bride's hands holding her dad's tie, a gift that she gave him on the morning of the wedding. I cropped out the faces to keep the focus on the detail rather than on the subjects' emotions.

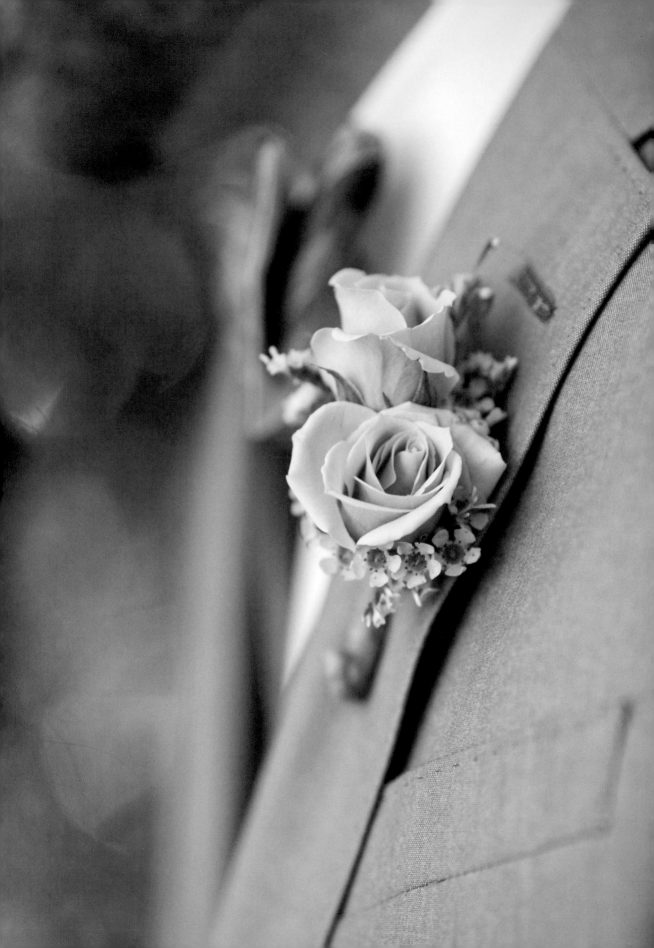

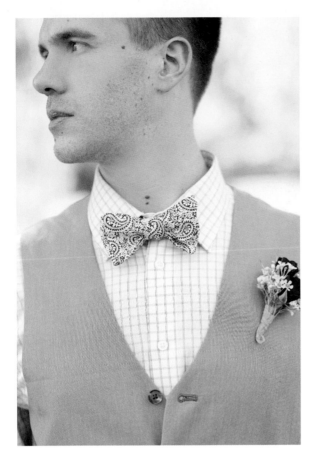

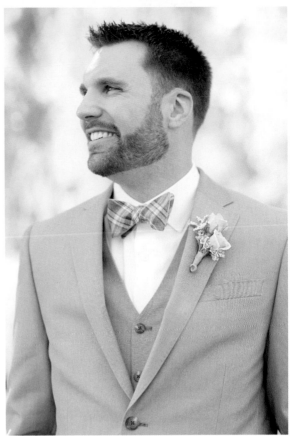

The Boutonnière *(previous page)*

Capturing a close-up of the groom's boutonnière is a must. There are multiple ways to photograph it while he is wearing it. Shoot a side view to show the inside of the flower and a straight-on angle to show off the groom's attire with the boutonnière as well.

Bow Tie Details *(above left)*

Each groomsman in this wedding donned a different bow tie. I wanted to capture a photo of each of the guys in his unique tie. For this image, I asked my subject to look off to the side. The pose helped to create an editorial feel in the image.

The Whole Picture *(above right)*

A front-on shot of a groom will help show his classy fashion as well as his boutonnière. Here, I used a wide aperture of f/2.8 to produce the beautiful bokeh in the background. As a result, the groom stands out in sharp focus and draws the eye, while the colorful background provides added interest.

Every wedding is unique. Take care to photograph special details in a way that pays homage to the personalities involved.

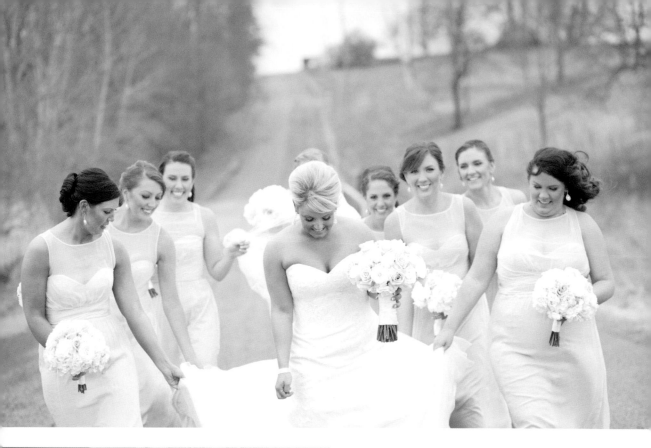

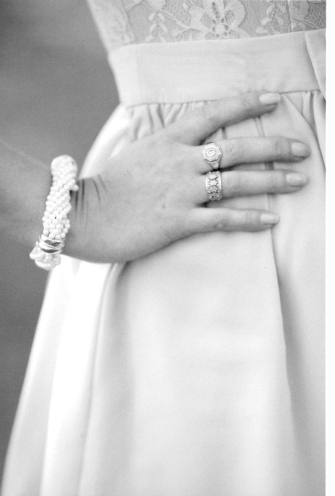

A Relaxed Formal? *(above)*

A formal shot doesn't always need to be super formal. Consider posing the group and asking the bridesmaids to turn toward the bride while smiling and laughing. The ladies' interaction with one another will make for a fun image filled with love—and it's something that everyone in the photo will certainly cherish for years to come.

Something for the Vendors *(left)*

Shoot accessories being worn to create a lifestyle and editorial feel. These pieces were purchased at a local jewelry store. Oftentimes it's easy to forget to document these details. By focusing on them, you now can present the vendor with an image that can be used for marketing.

Bridesmaids' Gifts

Photograph details when they are in use or being worn. Doing so will help to create a lifestyle or editorial feeling in your image.

The lovely lacy purse shown in this image was a gift from the bride to her bridesmaids. Because the women decided to carry their new bags on the wedding day, I opted to photograph the purse on the arm of one of the ladies. Creating an image like this is a nod to the bride's good taste—and she'll appreciate your attention to detail when she reviews her photographs after the wedding.

This image was made with a 135mm f/2 lens. My exposure was f/2.5, $^1/_{1250}$ second, and ISO 320.

A couple puts a lot of thoughts into choosing their attendants' gifts. Be sure to include photos of these items in the image collection.

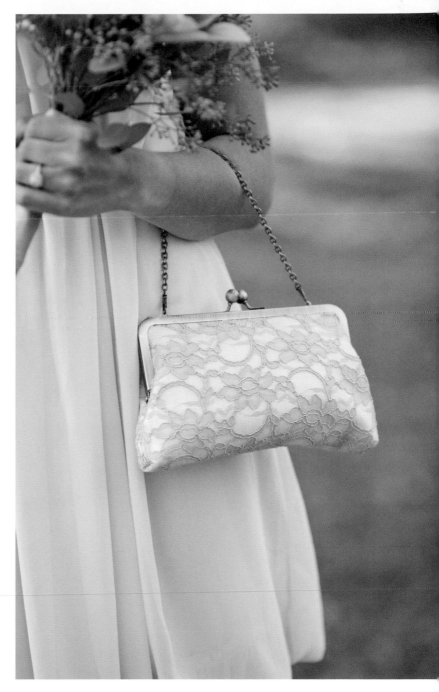

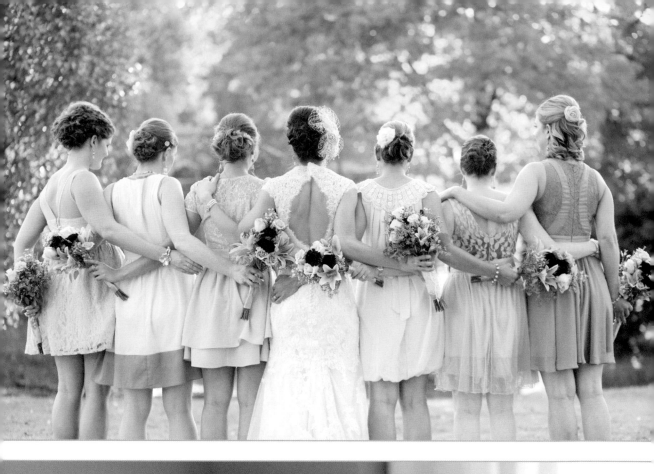
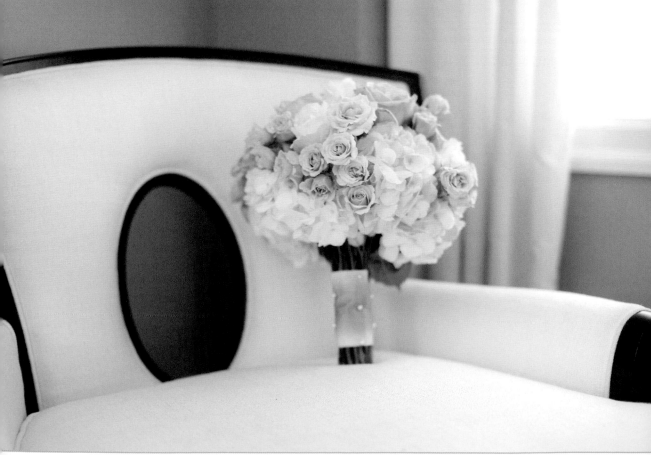

An Unexpected View

(previous page, top)

The bride's and brides-maids' dresses look amazing from the front, but the back of their dresses can be just as beautiful. Try photographing the ladies with their backs to you. Have them wrap their arms around each other while holding their bouquets. This shows off the backs of their dresses, their hair, and the bouquets and makes them look unified as a group.

Window Light

(previous page, bottom)

This bouquet was enormous! I was truly in awe when I saw it. From the little pearl details to the spray of roses, it was stunning.

As I wanted to emphasize the size of this bouquet, I shot from a low angle. The light from the adjacent window helped to reinforce the soft, romantic vibe of the elements in the frame.

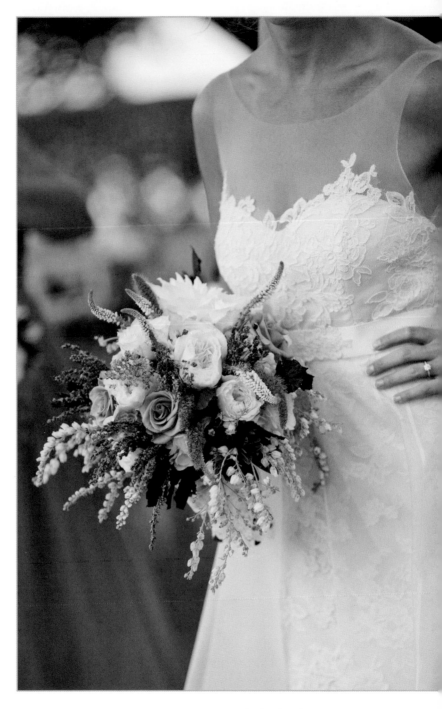

A Close Crop *(right)*

Another appealing way to capture a bouquet is in the hands of the bride. Cropping into the frame will draw the eye to focus directly on the flowers—not on the bride's emotions. Be sure to ask the bride to tip her flowers toward the camera so you can see the perfectly styled work of art in full effect.

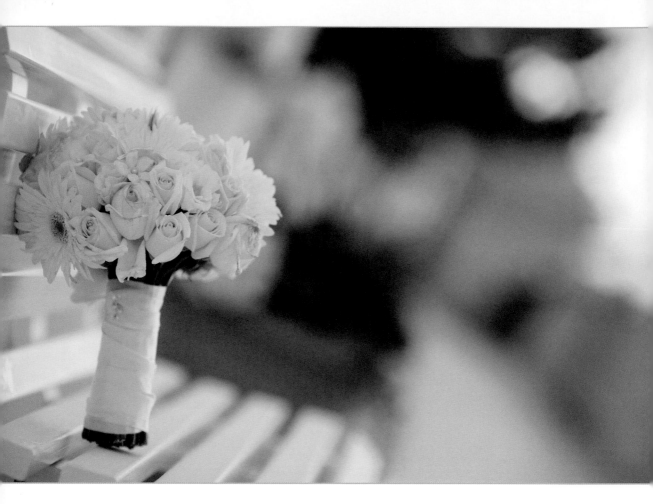

A Second Chance for Success *(above)*

If you are having a tough time finding a suitable indoor location to photograph the floral bouquet, look outside! Earlier in the day, I had photographed this bouquet in a less-than-favorable setting. After the introductions at the reception, I took the bouquet to a white bench. It was a beautiful setting and really made the flowers pop!

I usually recommend shooting the bouquet details upon arrival to make sure the flowers are look fresh and perfect—but this bouquet held up until the end, which gave me another chance to find the perfect setting. Bravo to the florist!

Brilliant Color *(following page)*

Here, an ornate carpet was rendered a soft wash of color through the shallow depth of field produced by using a wide aperture. With the distracting background diminished, the viewer's focus is able to remain on the exquisite, bold, and beautiful bouquet.

♥ *When possible, be sure to capture images of the flowers early in the day while they are fresh and look their best.*

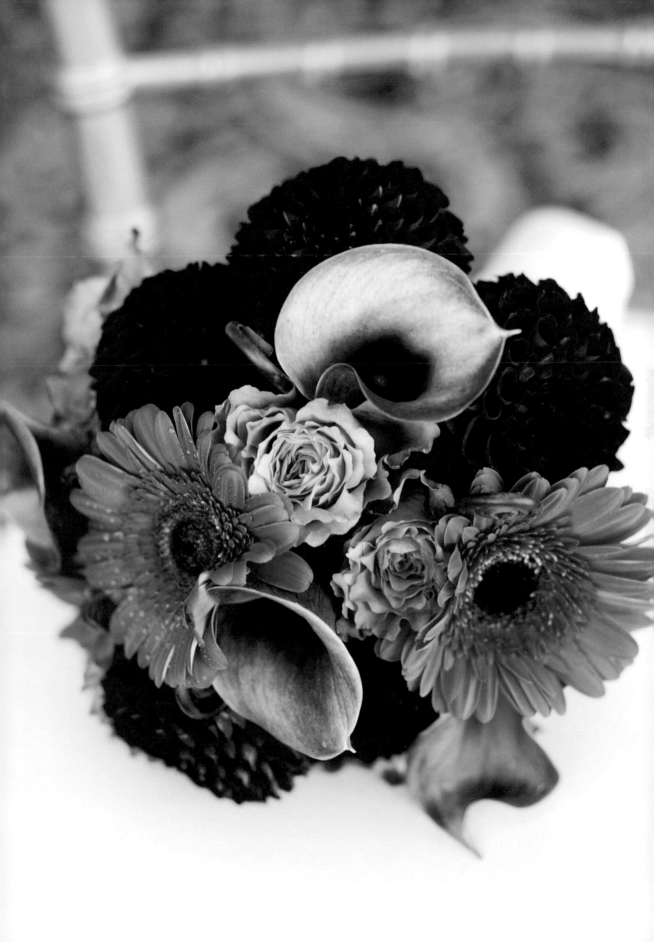

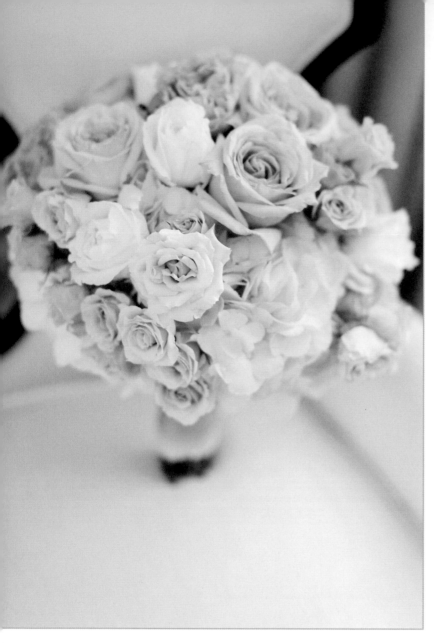

A Neutral Palette *(top)*

The soft pinks of the roses come to life against this neutral-toned backdrop. The dark back of the chair helps to frame the subject and draw the viewer's eye to the subject. I shot from a high angle to keep the attention on the beautiful, ultra-romantic blooms.

Side-Angle Shot *(bottom)*

As the bridesmaids are standing in a straight line for their bridal party portraits, shoot from a side angle with a shallow depth of field. By placing your focus on the flowers of a bridesmaid standing one or two people in, you will create a nice feeling of depth and repetition in your image.

Pure Elegance

(following page)

These white flowers are in sharp focus, but the gorgeous detail in the gown is soft, so as not to distract the viewer. The lace-like green foliage helps to create tonal separation in this predominantly white scene.

This image was captured with an 85mm f/1.8 lens. The exposure was f/2.5, $\frac{1}{5000}$ second, and ISO 320.

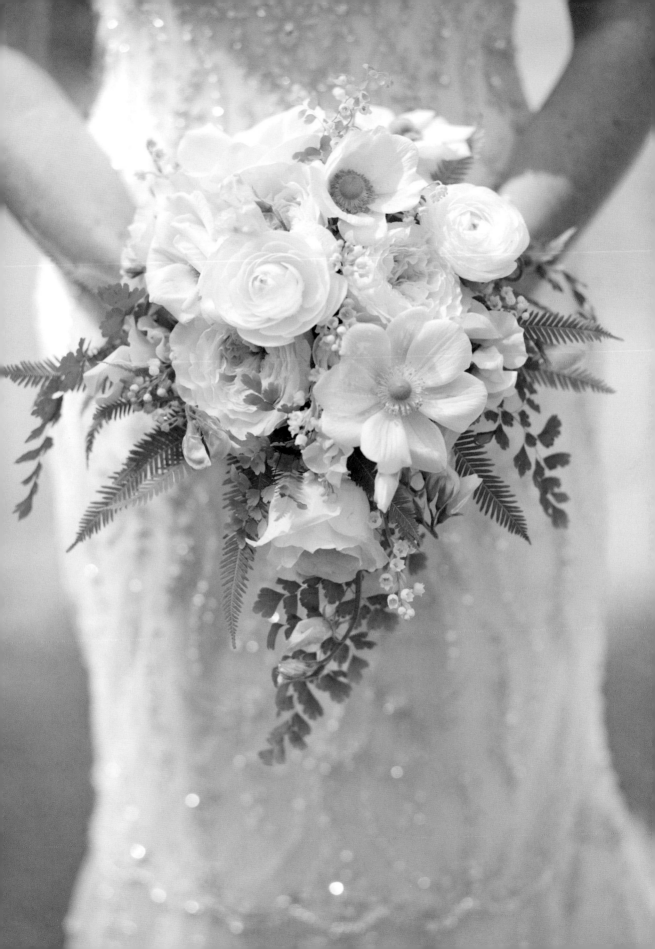

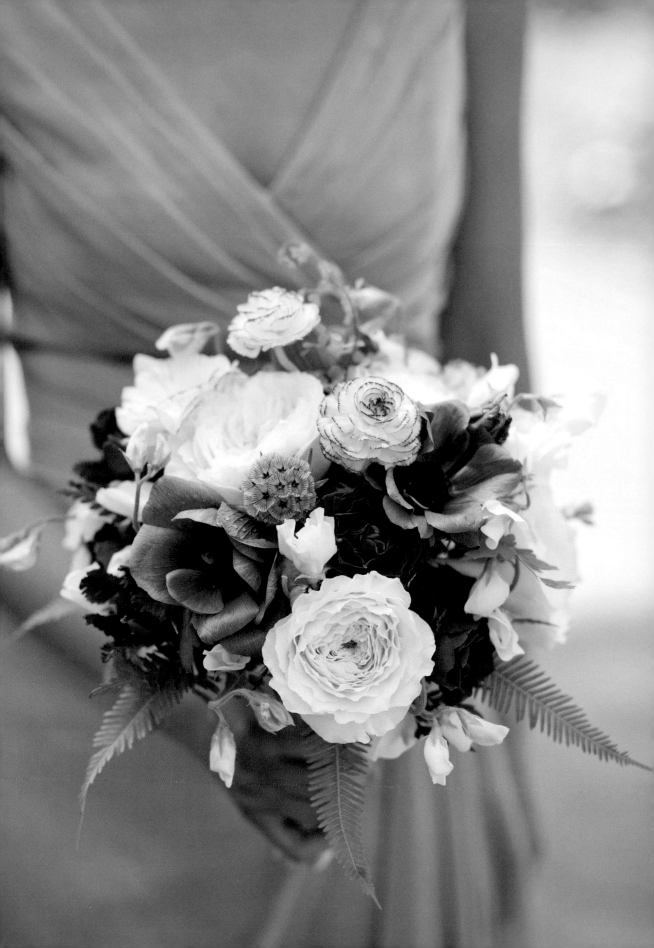

A Secondary Subject
(previous page)

I wanted to highlight the neckline of this bridesmaid's dress as, in this wedding, each of the ladies wore something different. The flowers provided a nice focal point while still showing off the dress design.

Juxtapositions *(top)*

I find it aesthetically pleasing to include contrasting elements in an image. For example, in this photo, I love the soft, delicate lace juxtaposed with the iron and wood of the chair. By shooting from a high angle, I was able to focus on the lace detail while rendering the surrounding environment in soft focus.

Tone on Tone *(bottom)*

Photographing items in the same color family results in a cohesive look and an image that is easy on the eyes. This floral kissing ball was so darling and looked lovely against the tulle skirt. I cropped around the floral detail and included a bit of the environment; this helped to provide a sense of place without detracting from the beauty of the detail.

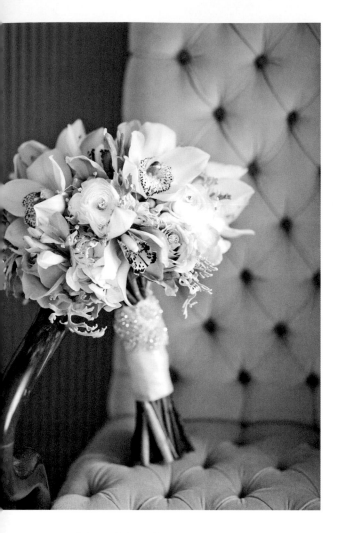

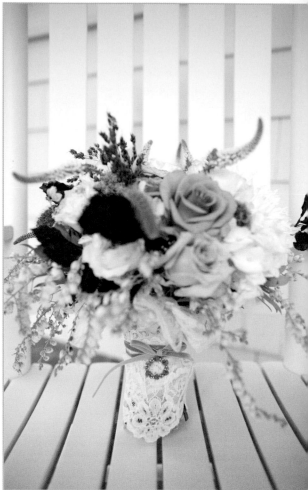

A Regal Backdrop *(left)*

I loved this chair! It has such a regal feel. By placing the bouquet off to one side, I was able to show the chair's design without it overpowering the subject. Be courteous when shooting: always wipe down the stems before placing the flowers on furniture.

An Unexpected Focal Point *(right)*

The stems of this bouquet were wrapped in a delicate handkerchief. I chose to photograph the arrangement at a 45 degree angle and used a wide aperture to shoot through the flowers. The fact that the flowers are in soft focus helps to lead the viewer's eye to the lower portion of the bouquet.

Portfolios and Blogs *(following page)*

A bridesmaid's dress in a lovely hue can make a great backdrop for a detail image of a beautifully crafted bouquet. A shot like this can prove to be a great addition to your blog or portfolio. You can also provide the image to the florist, who can help to spread the word about your work.

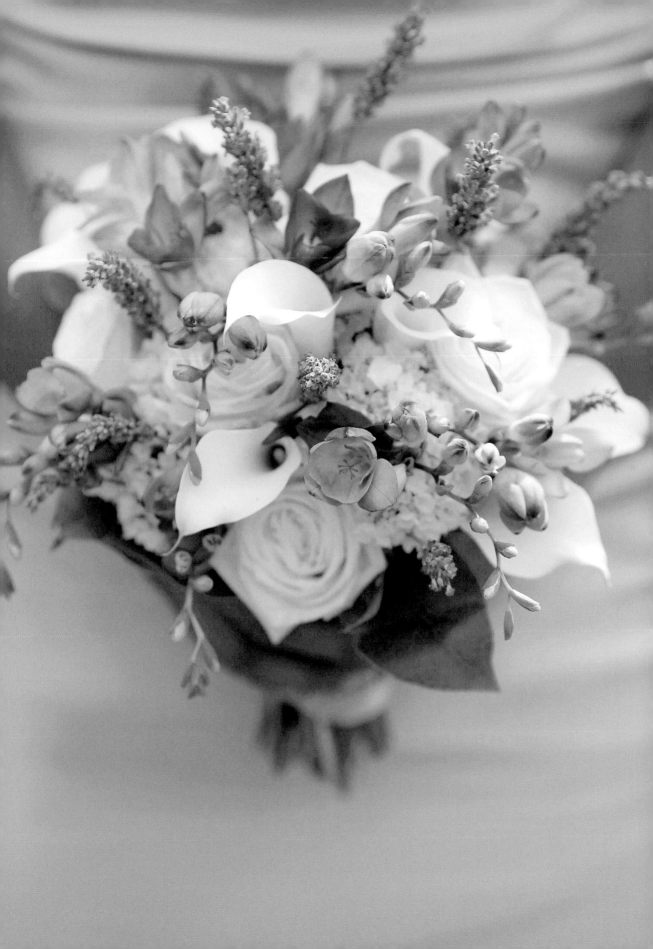

Selective Focus *(left)*

Focusing on a select portion of the bouquet or on a single flower within the arrangement can produce a distinctive look that's somewhat unexpected but highly appealing.

The View from the Top *(right)*

Floral designers create their masterpieces with the top of the bouquet in mind. By asking the bride to tip the arrangement toward the camera, you can ensure that the work of art is shown in all its glory! Also, having the bride hold the flowers in this position is a nice way to show how the bou-

quet looks next to the dress. Crop around the bouquet so that the image is about the flowers, not the emotion of the bride.

The Whole Picture *(following page)*

With the bouquet propped up on a chair, you can photograph the entire arrangement, including the stems. If you shoot with a wide aperture, you can take a couple of different shots: one in which the blossoms are the center of attention and one in which the focus is on the stems. The couple will appreciate the variety.

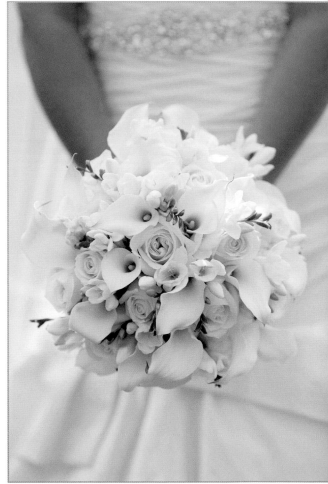

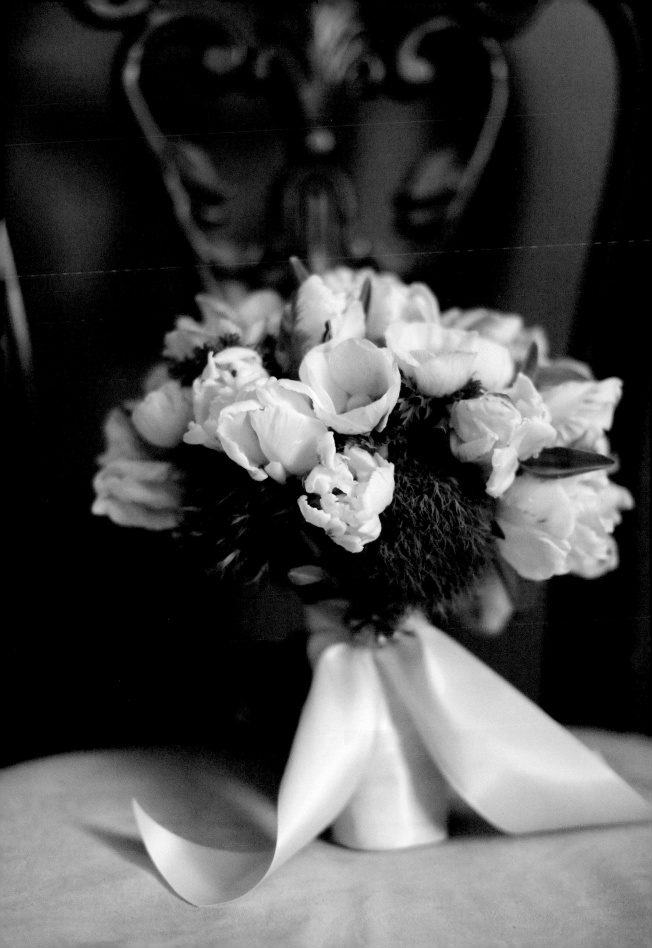

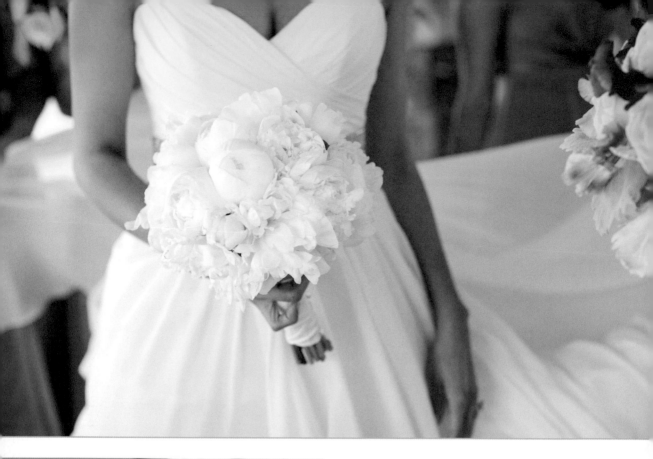

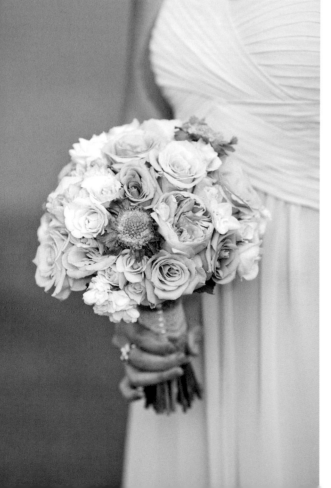

A Perfect Backdrop *(top)*

A stunning bridal gown can serve as a perfect backdrop for a detail image of the flowers. If the bouquet is all white like the dress, you can shoot with a low f/stop to create separation. In this instance, I included the bold colors of the bridesmaids' dresses in the image to frame the bride's bouquet.

Color Harmony *(bottom)*

In this wedding, each bridesmaid wore a dress of a different color. I loved how the soft pastels of the floral bouquet complemented this bridesmaid's dress. I wanted to highlight the bouquet but also show part of the corresponding dress color. I cropped the image with the subject to the side. The image contains equal parts nature and fabric, with the two elements tied together by the flowers.

Sentimental Details

(left) During my final meetings with the bride and groom, I ask if there will be any special sentimental details I should focus on photographing. This particular rosary came from Italy. It was part of the family tradition for the bride to carry it along with the bouquet. Styling the rosary and shooting from above with a shallow depth of field ensured that the eye would go directly to the detail.

(right) The fabric that surrounds the delicate stems of the bride's bouquet is sometimes significant. For example, it may be fabric from her father's tie or her mother's or grandmother's wedding dress. There may also be sentimental jewelry wrapped around the stems of her flowers. Look closely; if you see an out-of-the-ordinary treatment, take care to create an image that highlights the stand-out feature.

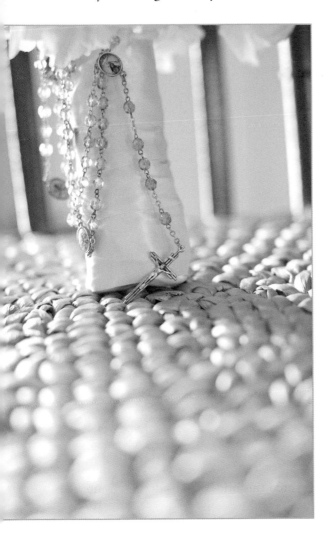

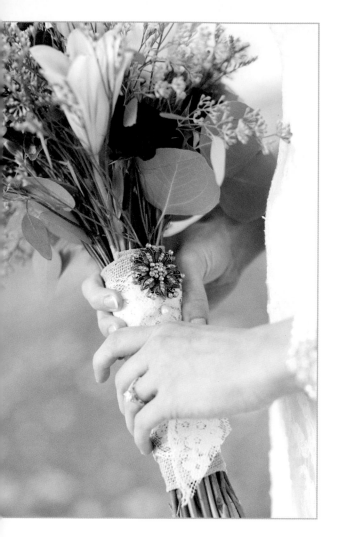

Something Blue (left)

When a bride incorporates her "something blue" into her bouquet, photographing the adornment is a must!

In this scenario, I had the bride stand in a profile position and hold her flowers at a 45 degree angle. I was able to focus on the elegant blue broach to produce an image imbued with meaning.

Sunset Glow (right)

The ceremony for this wedding was held at the most beautiful time of day, sunset— and the grounds and décor were stunning. Unfortunately, a downpour ensued minutes before the ceremony was scheduled to begin. Miraculously, the rain stopped and the sunset glow was magnificent.

When photographing the flowers placed on the ceremony chairs, I typically like to shoot from a high angle. In this case, however, I shot the detail from a lower perspective, as doing so allowed me to incorporate the rain-spattered foliage and romantic golden glow of the surrounding area in the image.

Symbolic Details *(top)*

There are many key moments throughout the day that make a good photo story great. Getting to know your clients on a personal level before the wedding day allows you to learn the backstory behind special details or rituals. Think of the "getting to know you" process as studying. With sufficient preparation, you'll be able to capture more meaningful images.

Moments before the mother of the bride walked down the aisle, her daughter gave her a corsage. As she looked down at the flowers, the mom realized that the corsage contained her own mother's favorite rose. You see, her mother passed away months before the wedding, so these flowers represented that she was there in spirit.

Perfect Light *(bottom)*

Take advantage of details in great light. This sign was placed by the entrance of the ceremony tent. It was lit perfectly from the side with soft, diffuse light. I shot from a slightly low angle to include a hint of the background and help tell the story of the day.

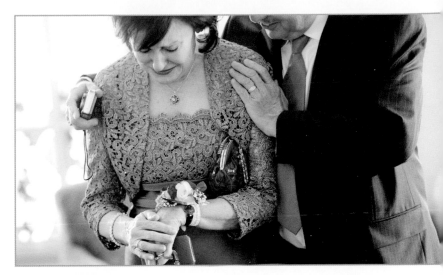

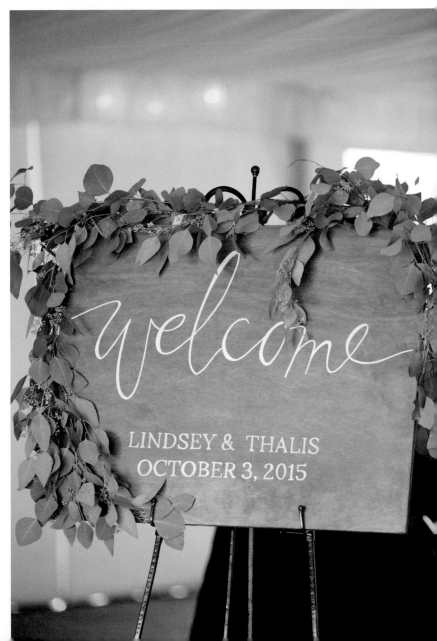

welcome

LINDSEY & THALIS
OCTOBER 3, 2015

Allie & Steve

October 12, 2013

A Dimensional Feel

(previous page) Creating the impression of depth in an image is key. Compose your shot to ensure that there is a foreground and a background, with your subject in the middle ground. Shoot with a low f/stop and focus on your subject. Everything in front of and behind the main point of interest will fall softly out of focus.

(top) Shoot the flowers or reserved signs at the end of the aisles using a wide aperture and from a low angle to fill the frame with the subject and create a sense of dimension in your image.

Soft, diffuse natural light and the light tones in this image lend a lovely, romantic vibe.

(bottom) Repetition in a photograph is very pleasing to the eye. To help create a sense of depth, shoot from a side angle and place your focus at the center of the repeating pattern. This will throw the foreground and background out of focus.

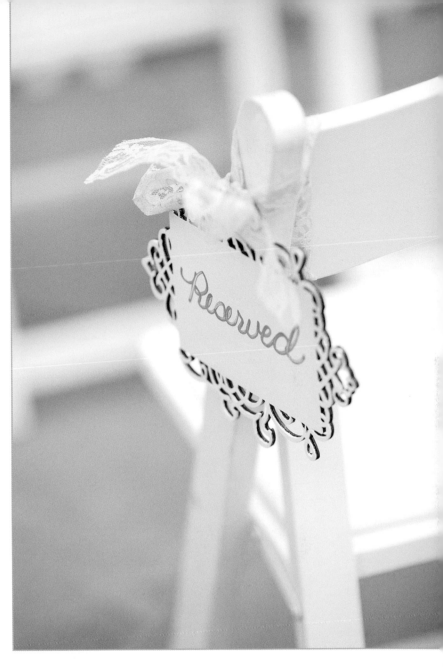

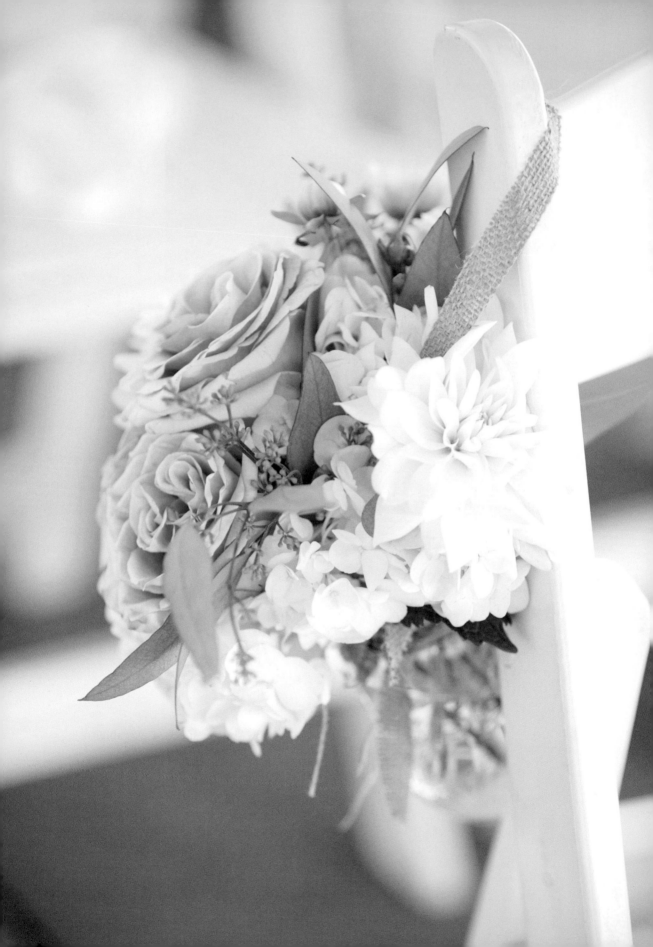

A Sense of Place

(previous page)

This tented ceremony space provided a great backdrop for a bright image. I wanted to be close enough to show the floral detail but also wanted to incorporate a hint of the surrounding chairs. By using my 85mm lens at f/2.5, I was able to accomplish both goals.

Tender Moments *(top)*

Just before the ceremony begins, look for opportunities to document the emotion of the couple's parents, family, and members of the wedding party. Here, I was able to show the connection between a flower girl and her grandmother.

A Wide-Angle View *(bottom)*

If possible, photograph the ceremony space before the guests gain entry. The bride and groom put a lot of effort into planning the details of the ceremony, and

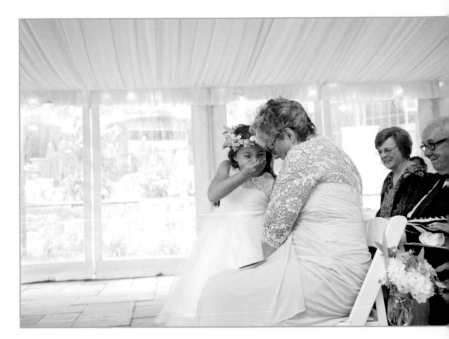

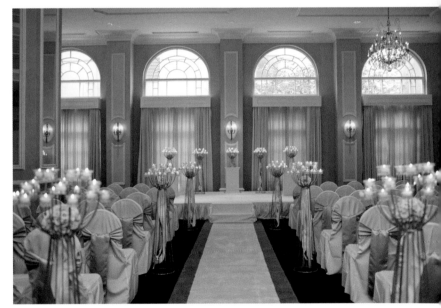

they will appreciate that you've taken the time to capture all of the important details. Additionally, such images are great to share with the venue for use in their portfolio.

I captured this image with my 35mm f/1.4 Canon lens. My exposure was f/2.2, $\frac{1}{40}$ second, and ISO 640. I used fill flash to ensure that the room was lit evenly and the windows would not appear blown out. By using a slow shutter speed, I was able to maintain the warm ambient-light effect of the candles and light fixtures. The result is inviting.

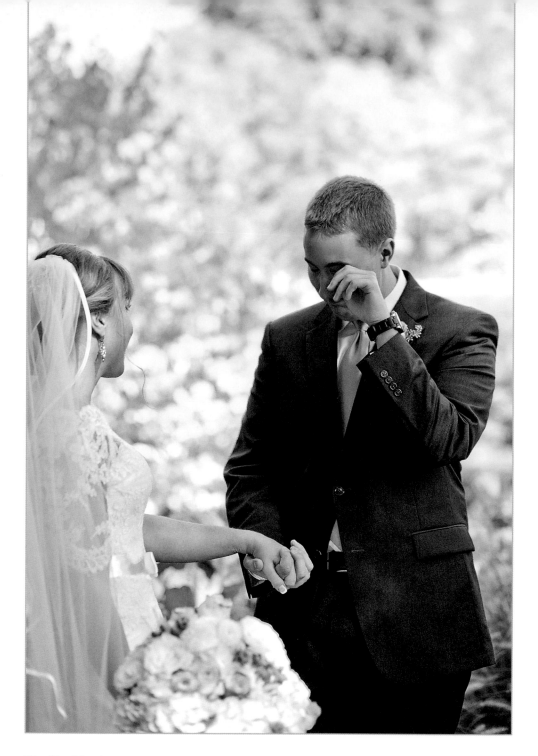

The First Look

I love to focus on the groom during the first look. His reaction to seeing his beautiful bride for the first time is priceless.

For a photo like this, position yourself so that the bride is in the foreground and stand slightly to the side so that you can photograph the groom's expression.

The Simplicity of
Black & White *(top)*

During the ceremony, the parents of this bride and groom were asked to circle around the couple in prayer. I chose to photograph from an angle to show the bridal attendants' faces. Shooting from this perspective also allowed me to show the pastor's closed eyes and the hands of the parents gracefully placed on those surrounding them. I converted the image to black & white to allow viewers to focus on the emotion in this touching image.

The Power of Touch *(bottom)*

Nothing shows love like a gentle touch. I cropped the image to exclude the couple's faces and focused on the groom's hand lightly placed on the bride's shoulder to show the tenderness of their physical interaction. As a result, the focus of the image is on the pure love between the couple, and there is a sense of mystery regarding what they are thinking as the moment unfolds.

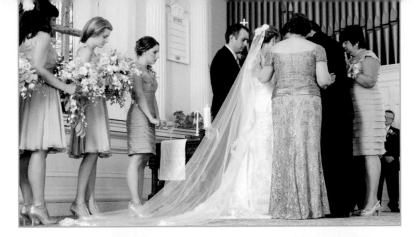

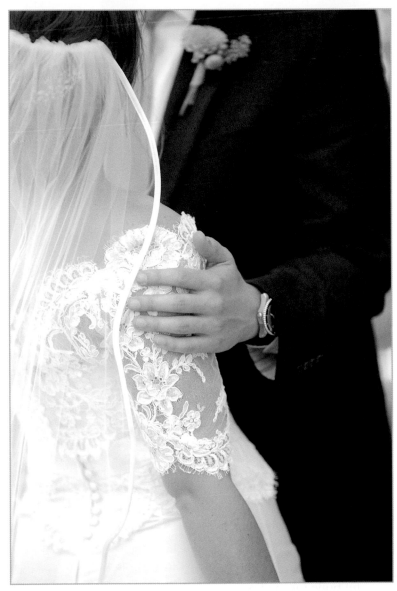

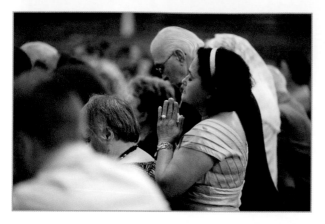

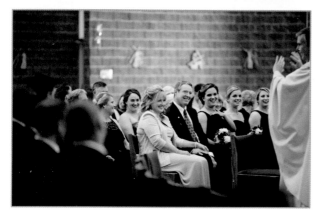

Reactions *(center and bottom)*

Some of the best reaction images are captured after the bride walks down the aisle. Before the procession, position yourself at the front of the aisle so that you can see the reactions of guests, but be mindful that you are not standing front and center. I typically crouch down and stay off to one side while shooting from the front. This way, I can get the shots I need without distracting the guests. The front row is typically reserved for family, so this is where I look first to find organic moments. Most couples aren't aware of these reactions because they are focused on seeing each other! When I scanned the first row, I saw the father of the groom in tears as he watched his son take his bride's hand. It was so touching.

Don't forget to capture a range of candid reaction shots of the sea of guests during the ceremony. Laughter and tears of joy are bound to occur for the newly married couple.

Architectural Detail *(following page)*

Capitalize on the beauty of the architectural detail in a church setting.

For this photograph, I wanted to make sure that both the bride and the intricate stonework were in focus. The bride's brother had passed away a couple of years earlier, and we wanted to take a photo to honor him. I asked my subject to place her hand on her heart and look upward. Just before I took the photo, the lights in the church went off. We shot the image in natural light. Immediately after the photo was captured, the lights came back on.

Prayer *(top)*

Throughout the ceremony, look to document peaceful moments and people taking part in prayer for the newlyweds. Moments like this can't be seen from the altar, so including these images will help the bride and groom to see the way the day unfolded.

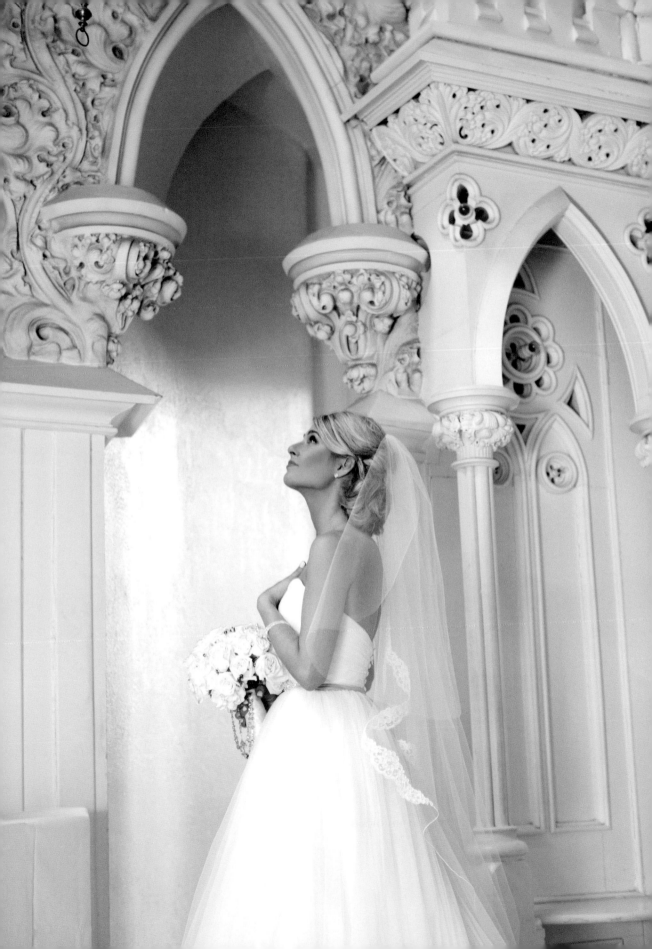

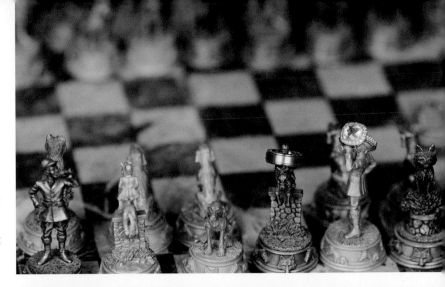

Innovate! *(previous page)*

The lining of this card envelope was so cute—I just had to incorporate it in a photo. Because the envelope was small, I knew it would be a perfect backdrop for a piece of jewelry. I decided to stage the bride's gorgeous engagement ring here and shot with my 85mm, my favorite lens!

A Personal Touch *(top)*

By using personal elements in the room, you can take a detail to the next level. This couple enjoyed playing chess, so styling their wedding rings with their favorite game made for a more meaningful image.

A Dramatic Look *(bottom)*

Shoot from a low angle with the subject positioned in front of a subtle background to lead the eye directly to the subject.

Here, an off-centered subject and the beautiful bokeh combine to create an image with a unique appeal.

I shot with my 24–105mm lens at a focal length setting of 105mm. The exposure was f/4, $\frac{1}{40}$ second, and ISO 800.

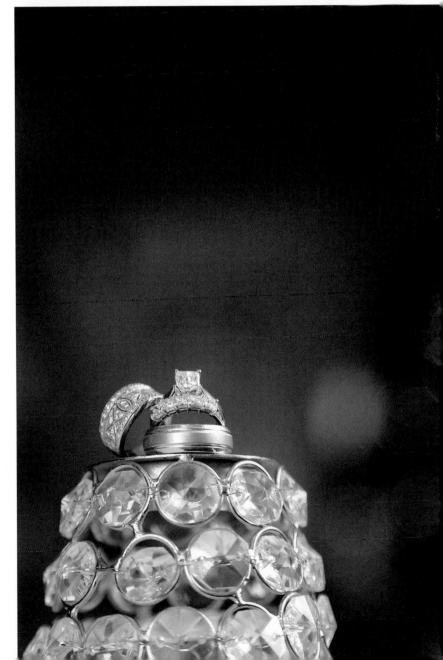

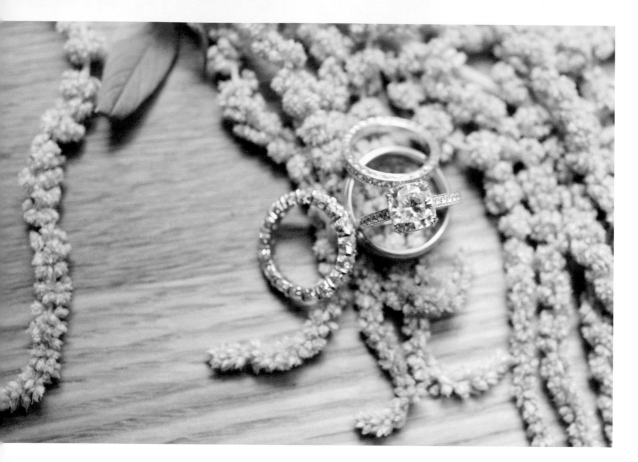

Directional Light

I like to look for ways to incorporate my surroundings when I am staging ring shots. The added elements help to make a more interesting photograph. In this case, I used some of the decorative florals and put them on top of the couple's custom-made cutting board guest book. I styled the shot so the focus was on the main diamond engagement ring with the couple's wedding rings surrounding it. The botanicals add a touch of softness, color, and texture and bring a visual rhythm to the image.

Look to your surroundings for creative ways to spice up the ring shots.

Because this photograph was taken in the evening, I directed my Canon 600 RT flash toward the tent wall to create nice, directional bounced light.

Engravings *(top)*

Let's face it. Rings are one of the smallest-in-size details to be photographed on the wedding day, but they sure are important. When photographing them, you'll want to crop in close and use a wide aperture to draw the eye. Here, photographing from a high angle allowed me to show the engraving in the groom's ring to best effect.

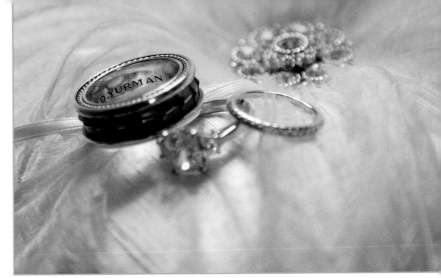

A 1920s Theme *(center)*

I love this bride's ring! She had planned a 1920s-themed wedding, and I was instantly drawn to the beading on her clutch. I thought the ring would look great sparkling on top of the beaded texture. I shot this with my 85mm and cropped in-camera to focus more on the diamond.

A Reflective Surface *(bottom)*

Shooting on a reflective surface and from a low angle creates a mirroring effect, which works great for ring shots. A macro lens is a must in order to capture any engraving details.

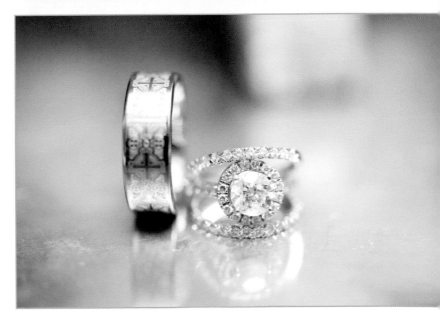

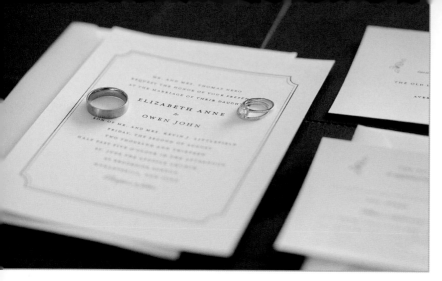

Contrast *(top)*

Using contrasting colors and depth of field within a photo allows the subject to easily be identified.

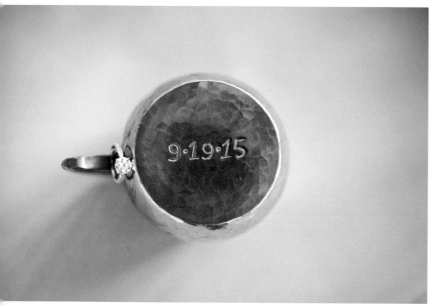

Organizational Tip *(center)*

I ask my clients to put all meaningful details in one area so that when I arrive, I don't have to bother them with a million questions. This item was a copper Moscow Mule mug with the couple's wedding date engraved on the bottom. When I flipped the mug upside-down, I discovered that the bride's diamond ring fit nicely on the side. I shot from above. With the diamond and the engraving on the same visual plane, everything was in focus.

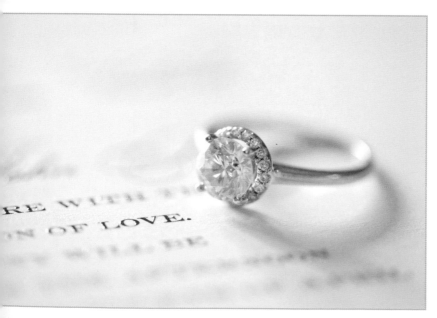

Invitation Details *(bottom)*

When I saw the word "love" on the couple's wedding invitation, I knew the piece would make a great backdrop for a photo of the bride's engagement ring. Using a macro lens, I was able to showcase both the word "love" and the diamond. Incorporating words in images of important details will increase your storytelling ability.

Shooting from a High Angle

(top) I placed this invitation suite on the floor and set up the bride's jewelry at the one-third point in the composition. The room was flooded with window light, which suited the tone of the invitations perfectly.

I photographed this collection with my 85mm f/1.4 lens. My exposure was f/2.5, $^1/_{125}$ second, and ISO 800.

(bottom) Incorporate all of the elements of the invitation suite in a single image and shoot from a high angle to show the cohesiveness in design.

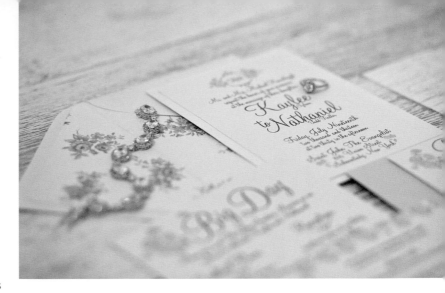

♥ *Get a shot of the invitation suite that shows the cohesiveness of the collection.*

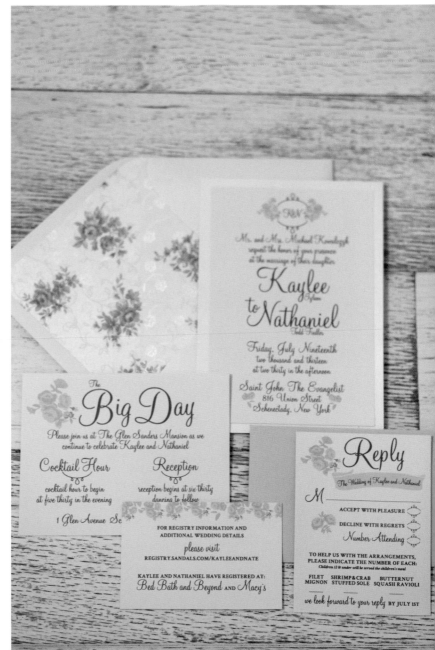

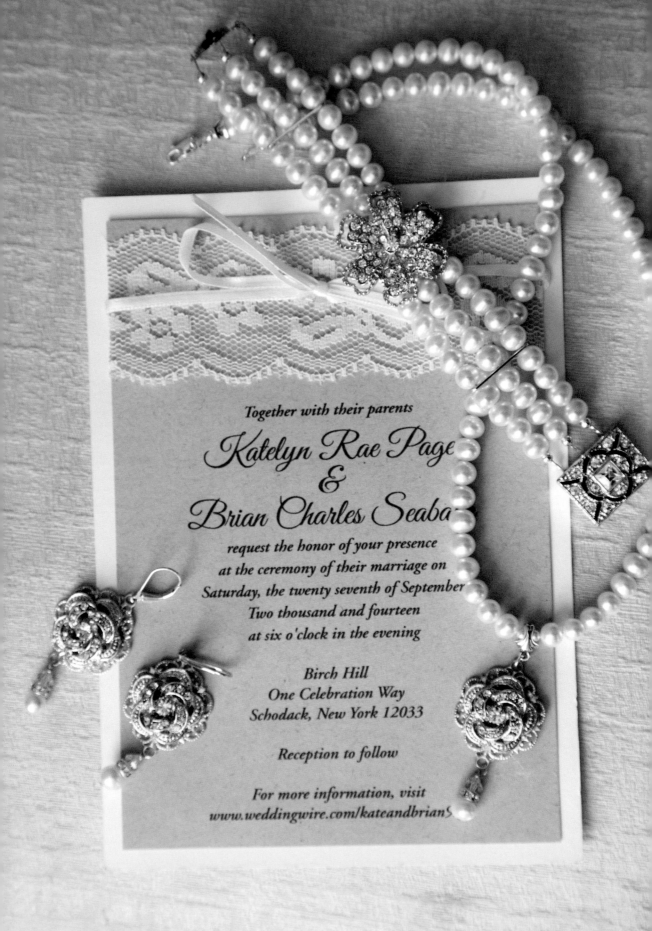

Together with their parents

Katelyn Rae Page
&
Brian Charles Seaba

request the honor of your presence
at the ceremony of their marriage on
Saturday, the twenty seventh of September
Two thousand and fourteen
at six o'clock in the evening

Birch Hill
One Celebration Way
Schodack, New York 12033

Reception to follow

For more information, visit
www.weddingwire.com/kateandbrianS

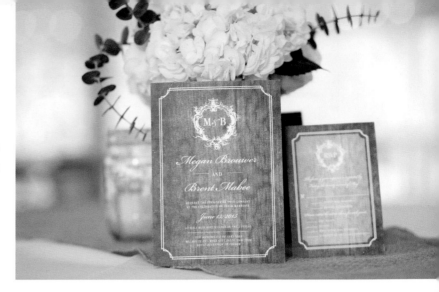

Cohesive Designs

(previous page)
I loved the way that my clients carried their vintage theme throughout the entire wedding, from the invitation to the jewelry. Because the styles complemented each other, I styled the jewelry around the invitation for a storytelling photo.

(top) I wanted to photograph this invitation in an area that complemented its rustic theme. I typically photograph the invitation in the bridal suite, but the reception tent was more appealing for this design. I loved the mason jars and the natural burlap table runner. I shot the backlit subjects from a low angle and used a shallow depth of field to create a beautiful bokeh effect in the background.

(bottom) I wanted an interesting background on which to place the bride's jewelry. I chose to make use of the same location shown in the previous image to continue the story. Because the jewelry is lighter in color than the table runner, it pops off the background and draws the eye.

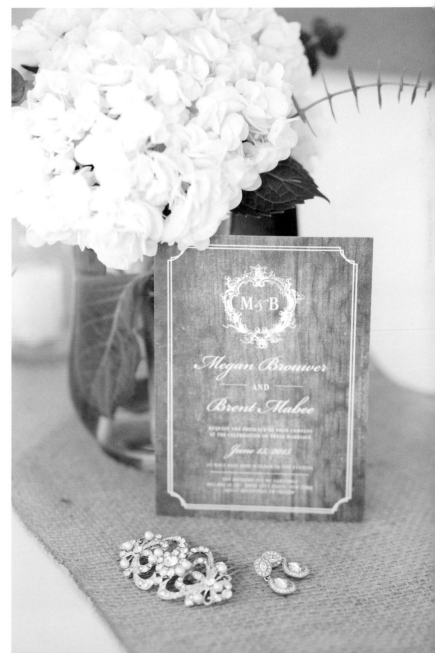

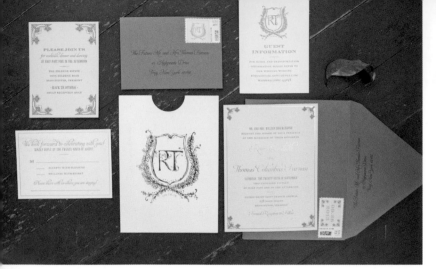

Repeating Lines *(top)*

When photographing items on a surface with repeating lines, place your subject(s) so that the lines run diagonally through the shot. This helps to provide a dynamic feeling and adds a bit of flair in an image. Photograph from directly above to show the rhythm of the leading lines throughout the image.

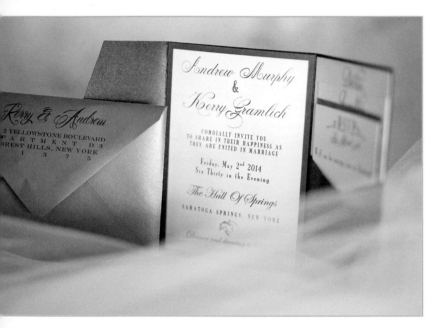

A Layered Approach *(center)*

Shooting through a foreground object while focusing on another subject can create a sense of dimension and add an appealing touch to what might otherwise be a very straightforward photograph.

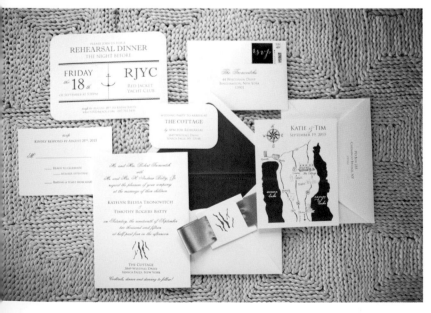

The Full Suite *(bottom)*

When photographing the full invitation suite, keep the designer in mind. They would want to showcase the design as a whole. Overlapping the objects will help to create a sense of unity.

I captured this image with my 24mm f/1.4 lens. My exposure was f/2, $^1/_{1250}$ second, and ISO 1250.

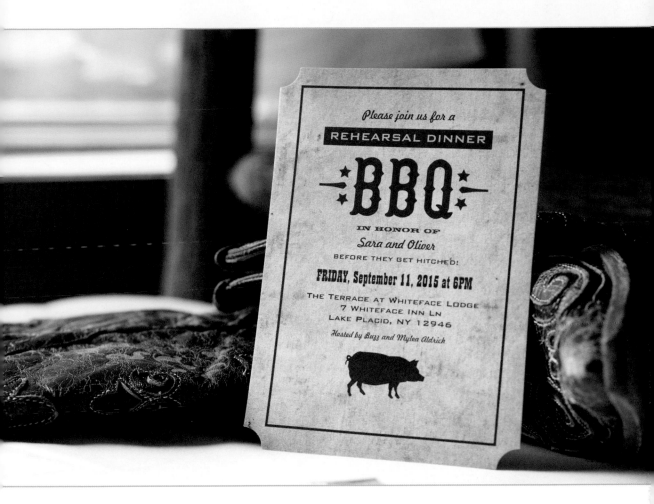

Please join us for a

REHEARSAL DINNER

BBQ

IN HONOR OF

Sara and Oliver

BEFORE THEY GET HITCHED!

FRIDAY, September 11, 2015 at 6PM

THE TERRACE AT WHITEFACE LODGE
7 WHITEFACE INN LN
LAKE PLACID, NY 12946

Hosted by Buzz and Mylea Aldrich

Special Gatherings

Surrounding the wedding day, there are usually gatherings with family, like the rehearsal dinner. While such an occasion is separate from the wedding day, it is still part of the event as a whole.

I loved the rustic feel of this couple's rehearsal dinner invitation, and it paired nicely with the bride's cowboy boots. I set the boots on a chair with a wooden back, which I felt added to the overall casual, country theme. I shot from a low angle to get the best view of the invitation while showing a hint of the environment.

I photographed this scene by window light using with my 85mm f/1.8 lens. My exposure was f/5, $^1/_{100}$ second, and ISO 800.

When possible, document items that relate to events that fall around the wedding day.

Taking Direction

(previous page)

Photographing signage is all part of showing the couple's overall wedding theme. Be sure that you compose the image to ensure that any writing on the sign is fully readable, and make sure that the background does not detract from the subject.

Stand-Out Signage *(right)*

Try to photograph signage from a slight angle. Shooting an object straight on is the norm, so mix things up and take a step to the side to create a more interesting photograph. Take your image to the next level by including something in the foreground to shoot through.

Whether clever or traditional, signs placed around the wedding venue make a statement about the couple and their special day.

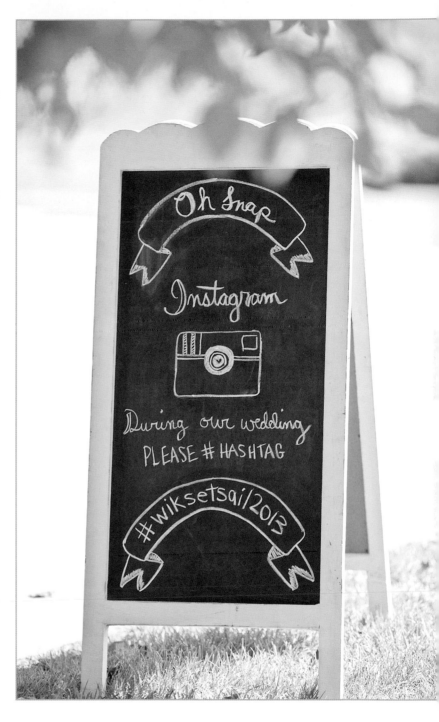

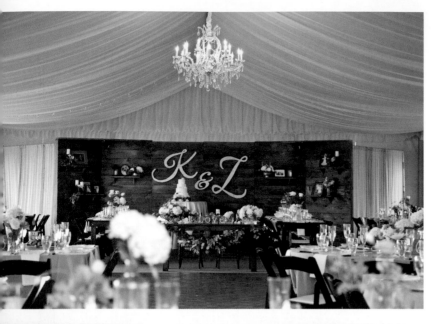

The Head Table *(top)*

Photographing the head table during cocktail hour is key. Using a wide-angle lens and shooting through the details on another table will create great depth.

Here, I used fill flash to ensure that the chandelier bulbs would glow and not appear overexposed.

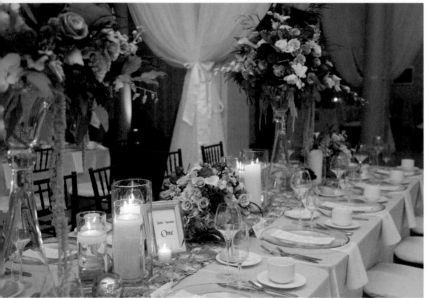

Exquisite Staging *(center)*

This is one of my favorite reception shots! There were so many lovely details that I was in awe. The texture of the table runner, the different heights of the candles, the flowers—everything was simply exquisite. To get the shot, I stood at a slight angle where I could see the table as a whole. I photographed from a slightly downward angle to capture the linens, the details, and some of the room.

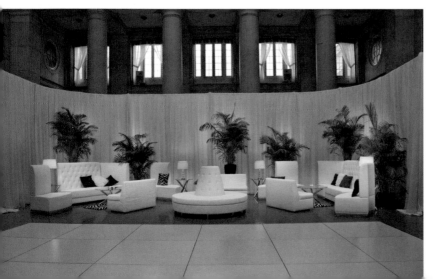

Large Rooms *(bottom)*

Room shots are essential to showcasing the décor. This reception had a lounge set up, and I wanted to show the entire room. To ensure all of the elements were in focus, I shot with a wide-angle lens and a high f/stop. The light levels at a reception are often low, so fill flash or off-camera lighting is necessary.

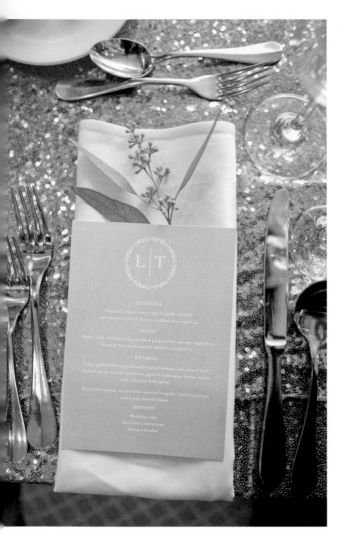

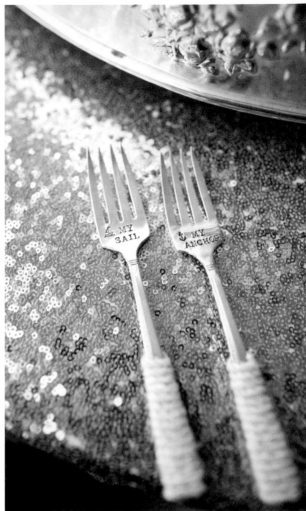

All That Glitters *(left)*

For this image, I shot from overhead to capture the menu card and floral details that were placed at each seat. I wanted to highlight the reflective nature of the sequined table linen. By directing my flash from the side, I was able to capture the sparkle.

Broad Light, Soft Shadows *(right)*

Typically, you'll find some additional details next to the cake. In addition to the traditional cake-cutting and serving utensils, the bride and groom who planned this reception purchased custom forks with an engraved detail. Placing metal objects near a broadly lit space (like a window) helps to diminish the appearance of any dark shadows in the metal. Here, shooting from overhead allowed me to effectively capture the engraving detail that was so personal to the couple.

I shot this image with my 24mm f/2.4 lens. The exposure was f/2.2, $^1/_{60}$ second, and ISO 1250.

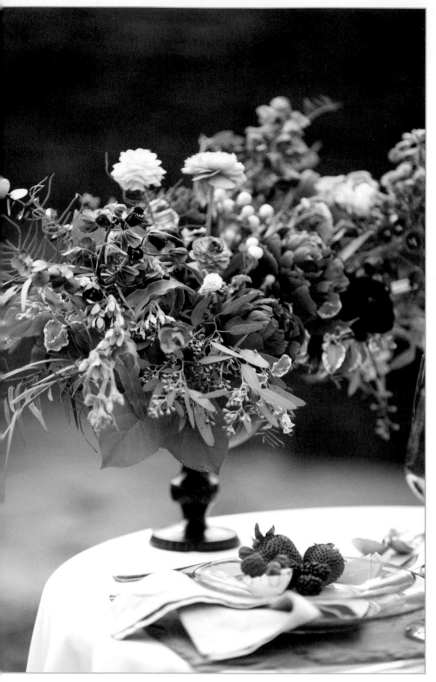

A Perfect Pairing

(following page) A bird's-eye view was a must when it came time to photograph this tabletop! The clear dishes with the natural stone charger were absolutely stunning. An overhead camera angle was truly the best choice for capturing these details. The beautiful, plated ripe berries and the pretty pink napkin between the upper and lower plates help to show each element beautifully.

When you are photographing a stacked place setting, use a wide aperture to create a primary point of interest.

(left) I also took the opportunity to capture a complementary side angle shot of the same table. In this photograph, the floral arrangement is the primary point of interest.

Unique views of a single setting will offer viewers a variety of ways to admire the details.

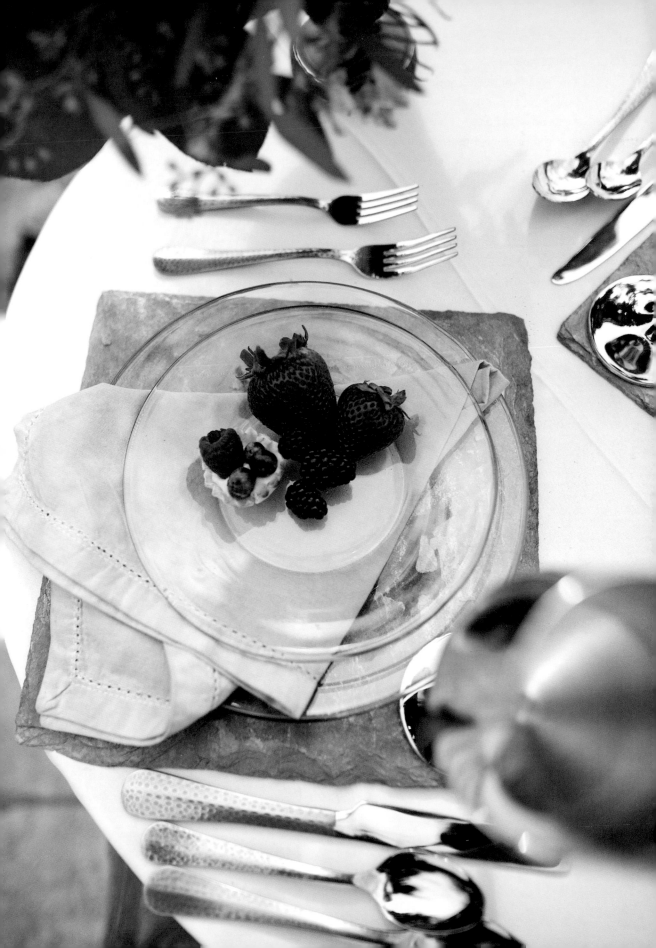

Favors (top left)

The gleam of these copper Moscow Mule mugs and the thoughtfully prepared recipe cards attached to each handle are details that the bride and groom will be happy to find in their image collection. Soft light, a side view, and a shallow depth of field created additional visual appeal in this setting.

Creative License (bottom left)

You can choose to focus your lens on any of many items that comprise the table setting; simply be sure that the surrounding elements tie in to the item you decide to feature.

In this image, I chose to focus on the stir-stick flag that reads "love." Because a wedding day is filled with that emotion, it only made sense to capture the detail with the bride and groom in the background.

By shooting at f/2.2, I was able to blur the other image elements and draw attention to the object I chose to highlight.

Special Thanks (right)

I shot this detail through the cocktail hour crowd using my Canon 135mm lens. This lens allows me to be at a distance yet focus on so many key elements that make the wedding day personal.

A Grand View (following page)

I try to find an angle of the room that has the most depth. By doing so the image appears more grand. I typically find myself shooting from a corner to get this effect. Photographing from a slightly lower angle makes the centerpiece arrangements appear bigger, too.

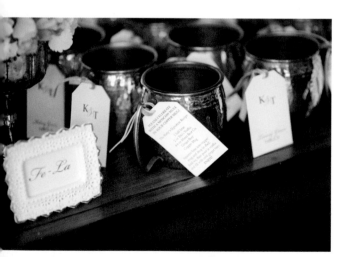

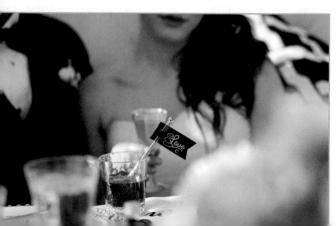

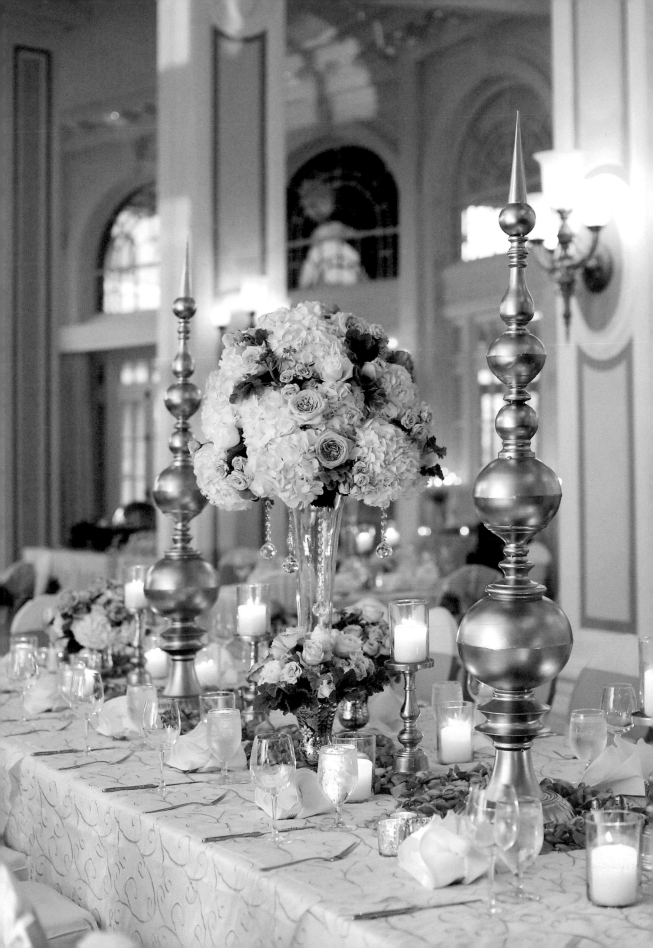

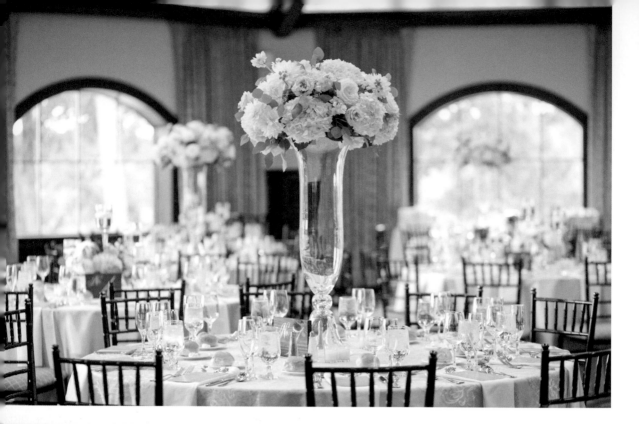

A Little Fill Flash *(top)*

This reception room was filled with a lot of windows and natural light. The centerpieces were light in color, and I didn't want the flowers to get lost in the brightness of the window. I composed the image so that the flowers were in front of the curtains, and this allowed them to stand out. Shooting into the window required me to use fill flash to brighten up the front of the centerpiece.

Beautiful Bokeh *(bottom)*

I love shooting reception rooms that are lit with bistro or string lighting. It creates a bokeh effect that is just so pretty! The main focal points in this image are the signs and garland draped around the head table chairs. I shot from a low angle to show the lights in the background, as I felt they added an appealing element to the image.

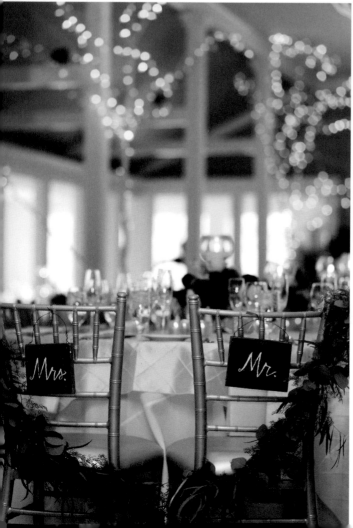

Layers of Visual Interest *(left)*

This place setting was stacked with so many lovely details. By shooting from a side angle, I was able to show the layers beginning with the charger and ending with a fluffy peony.

Balance *(right)*

Balancing a tall centerpiece with smaller table details requires the right lens and lighting. In this image, I wanted to highlight the grand centerpiece but also the small candles and place setting. By standing at a distance using Canon's 85mm (for aesthetic purposes), I was able to capture the scene from top to bottom. I used my Canon 600 RT flash to bounce light off of the white tent ceiling. This provided fill light and highlighted all the smaller details I didn't want to miss.

Create a perfect shot. Check your histogram to avoid blown-out highlights or blocked-up shadows.

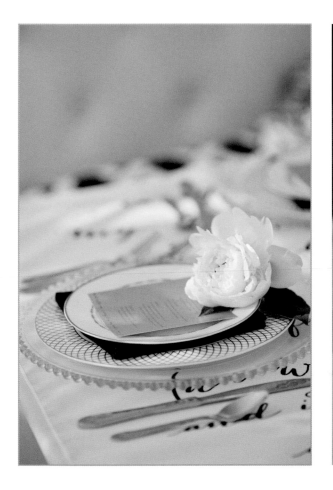

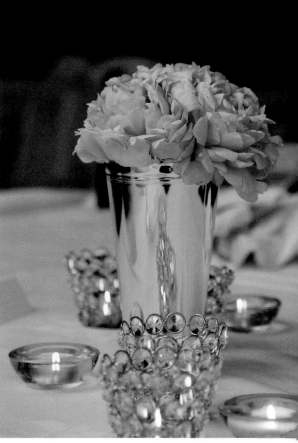

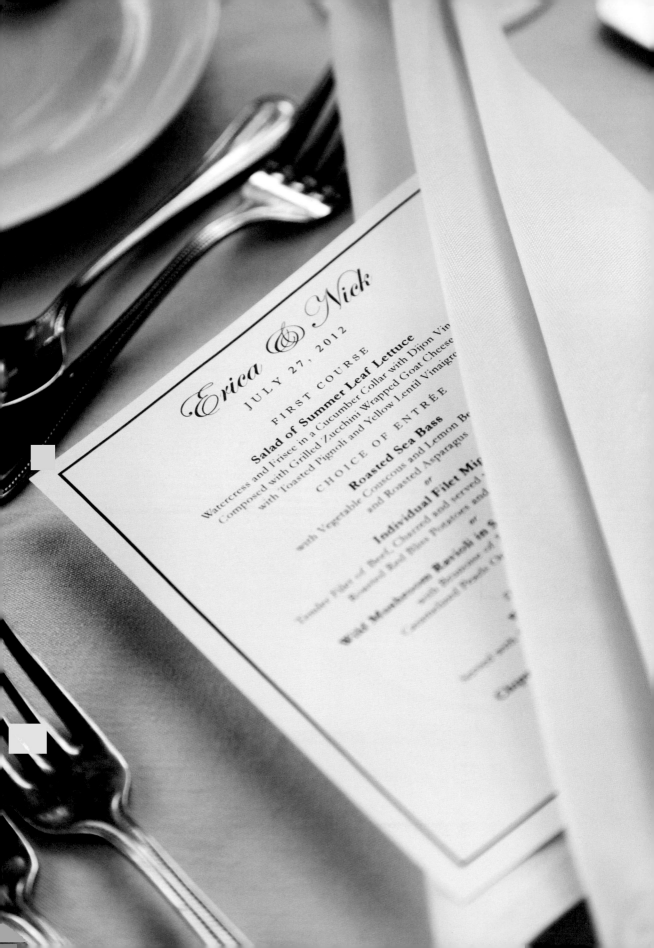

Erica & Nick

JULY 27, 2012

FIRST COURSE

Salad of Summer Leaf Lettuce
Watercress and Frisee in a Cucumber Collar with Dijon Vin...
Composed with Grilled Zucchini Wrapped Goat Cheese...
with Toasted Pignoli and Yellow Lentil Vinaigre...

CHOICE OF ENTRÉE

Roasted Sea Bass
with Vegetable Couscous and Lemon Be...
and Roasted Asparagus

or

Individual Filet Mig...
Tender Filet of Beef, Charred and served...
Roasted Red Bliss Potatoes and...

or

Wild Mushroom Ravioli in S...
with Rosemary d...
Caramelized Peppers O...

Photographing the Menu *(previous page)*

Shooting a bird's-eye view of the menu is the best way to document the menu card in its natural setting. Using a wide-angle lens is typically the best way to achieve the desired look.

Seating Assignments *(top)*

There are many unique ways to display a seating chart for guests. Because this wedding was on the beach in the Hamptons, the couple incorporated sand dollars. I chose to shoot from a slightly high angle to show that the cards were presented in a tray, atop sand.

A Follow-Up Shot *(bottom)*

This is a follow-up shot to the first image of the place cards. Between each box of sand dollars, there was a starfish, which supported the nautical/beach theme. I wanted the viewer to know where the starfish were placed, so I photographed from an angle to show that they were between the cards.

Balanced Lighting *(top)*

In this setting, I had to balance window light and the candles on the table. I didn't want the image to be overexposed, especially because there were candles involved. By using a little fill flash and positioning myself next to the window, I was able to get the exposure I was looking for.

The Bride's Place Card *(bottom)*

Place cards are a nice detail to capture, especially when it's the bride's card, marked with her new last name! Be sure to shoot at a low angle to focus on the typography.

Mixed Lighting *(following page)*

Artificial light, candle light, and window light illuminated this room. To create the perfect exposure, I used a little fill flash from my Canon 600 RT. Because flash stops movement, I dragged the shutter at $1/40$ second, which allowed me to bring in some of the ambient lighting without overexposing the flames. I manually set my camera's white balance to ensure natural color in the image and shot with my 24–105mm lens and cropped in-camera to get the composition I desired.

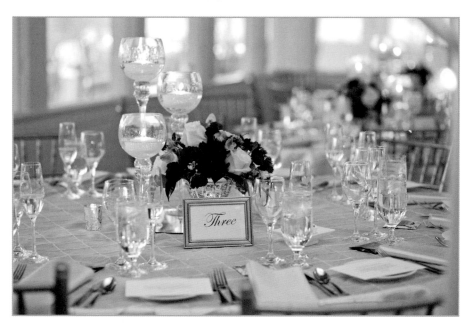

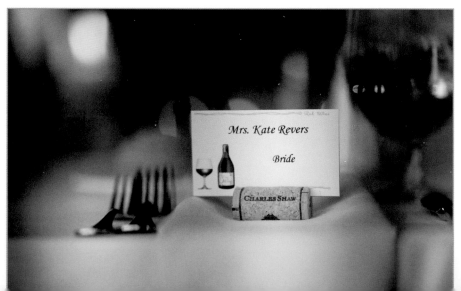

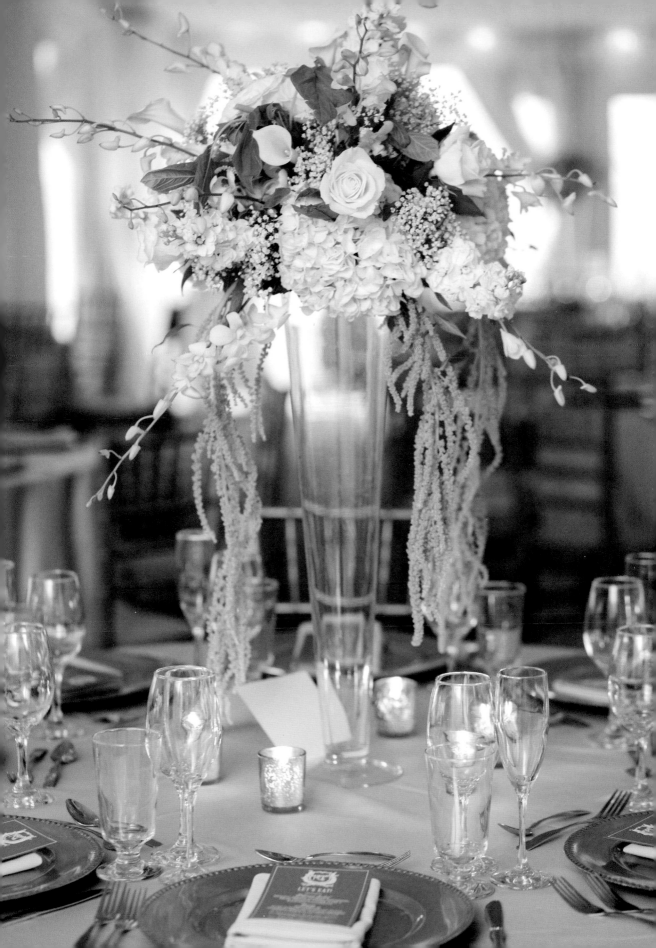

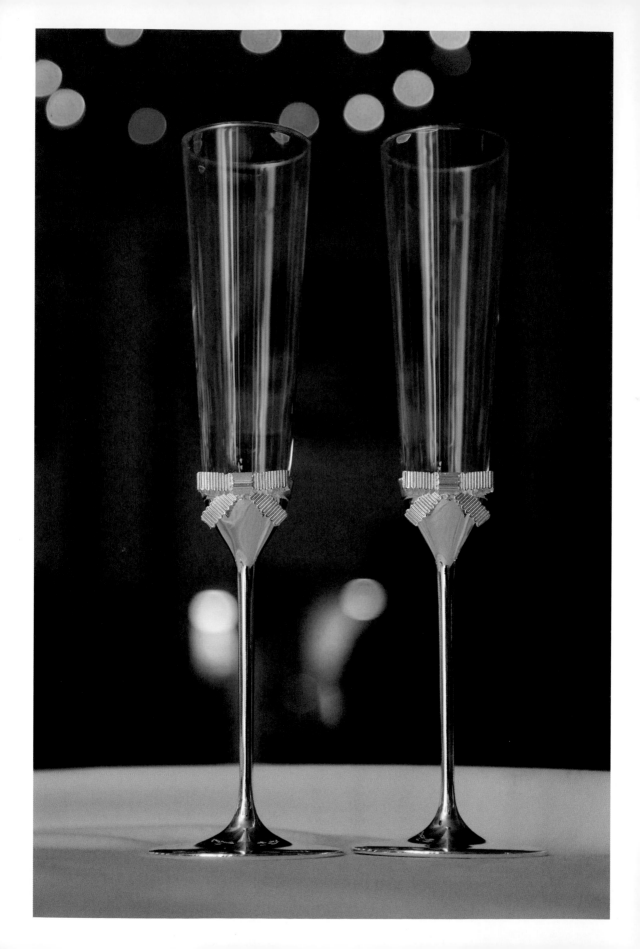

Toasting Glasses

(previous page)

Toasting glasses are a common detail to photograph when covering the reception. Because they are glass, you have to be strategic when placing them. I typically find that moving them toward the edge of the table and shooting from a angle helps the glass to really stand out in a dimly lit environment.

A Tonal Gradient *(right)*

When working in dark reception rooms, you can create a gradient from dark to light by including the surrounding environment. In this image, I used a wide aperture to produce a shallow depth of field and cropped in tightly around the floral arrangement. You can see the dark ceiling and a hint of light. As your eye moves down the image, you can see that the table-cloth brings an element of brightness. When shooting with flash, this surface can also help fill in the flowers with light.

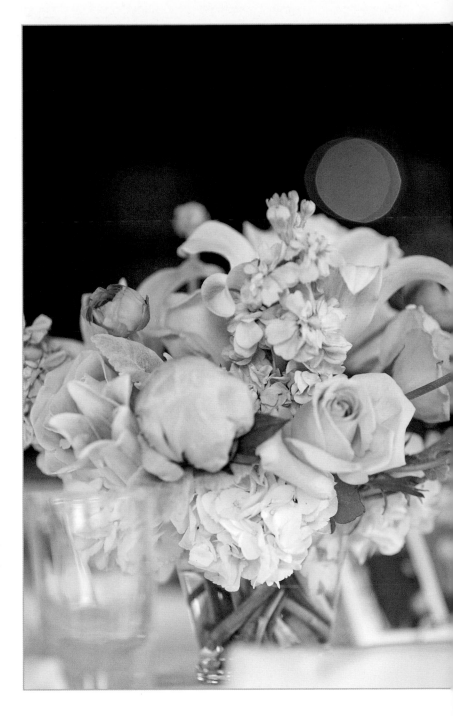

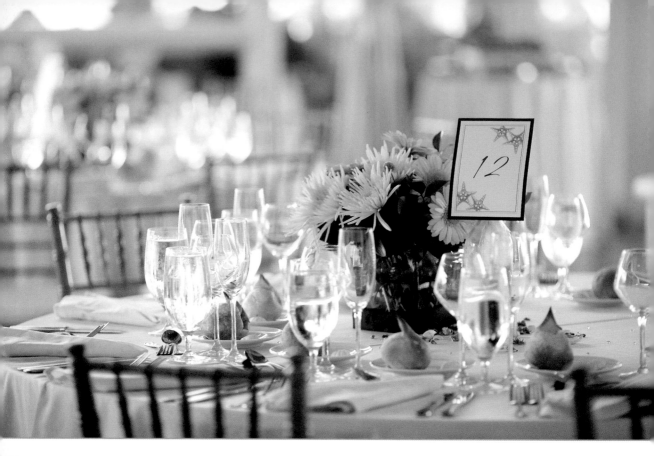
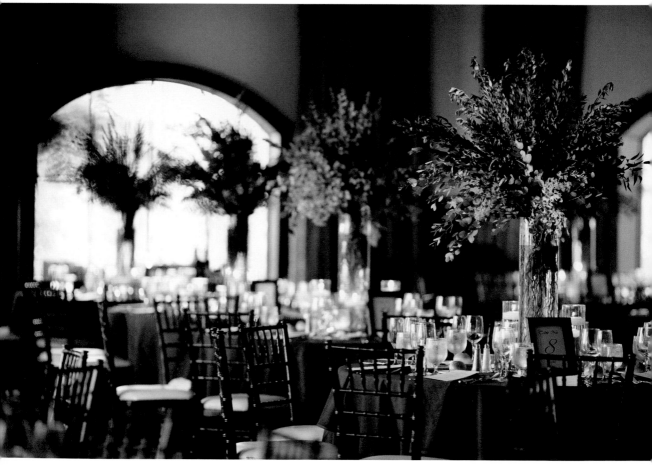

Enhancing the Setting

(previous page, top)

In this photo, I wanted to focus on the table number. When capturing the details on a table, be sure to remember to remove the salt and pepper shakers. They can be an eyesore in a lovely setting.

Using the rule of thirds, I composed this image so that the focal point was off center for a more aesthetically pleasing image.

Dramatic Uplighting

(previous page, bottom)

I love when a reception room has uplighting. I think it adds another element of interest, especially when the centerpiece color is different from the color of the light. In this case, the green flowers pop against the purple backdrop. These centerpieces were so grand and lush—the entire room was changed.

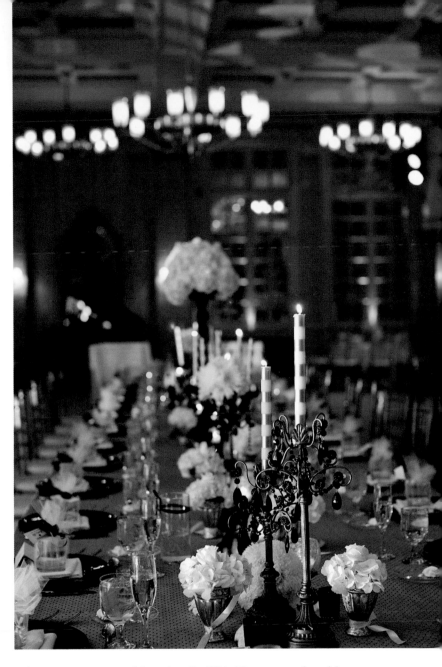

Shooting from the side when photographing tables can emphasize the grandeur of the setting. By focusing on one centerpiece and shooting at a low f/stop, the image becomes visually appealing.

A Touch of Tuscany *(right)*

Utilizing mirrors in a ballroom is great for achieving directional light when photographing details. This Tuscany style table setup was grand in its décor. I knew the light would play a huge role in capturing the scale of the table. Using my Canon 600RT flash, I was able to bounce the light off a nearby mirror and fill in the details with light from the side.

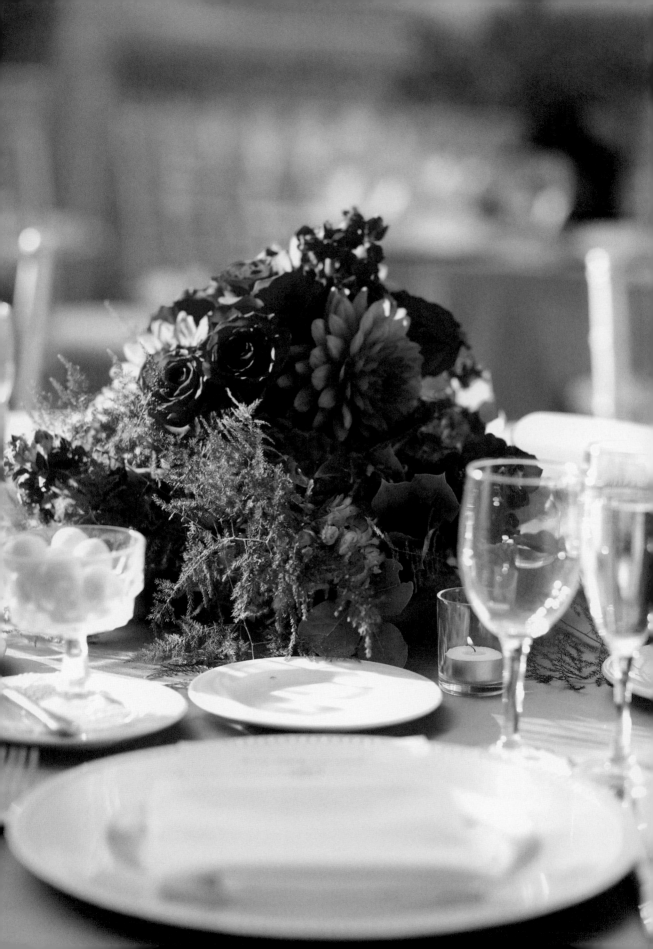

Color Temperature

(previous page)

Because I am based in upstate New York, it is not often that reception spaces are set outdoors without cover. This particular wedding took place in Southern California, the perfect location for an outdoor reception. I wanted to take advantage of the warm light on the centerpiece. Shooting using a warm white balance (cloudy or shade) can enhance the feeling of warmth.

Floral Arrangement Details

(right)

Within the floral arrangements, it is common to see other elements that make for a cohesive, styled design. Items like hanging crystals often get lost when showing the centerpiece as a whole. Once you've focused on the overall arrangement, get in a little closer and focus on all of its smaller components. Shoot with a low f/stop to focus on those details and minimize other distracting elements.

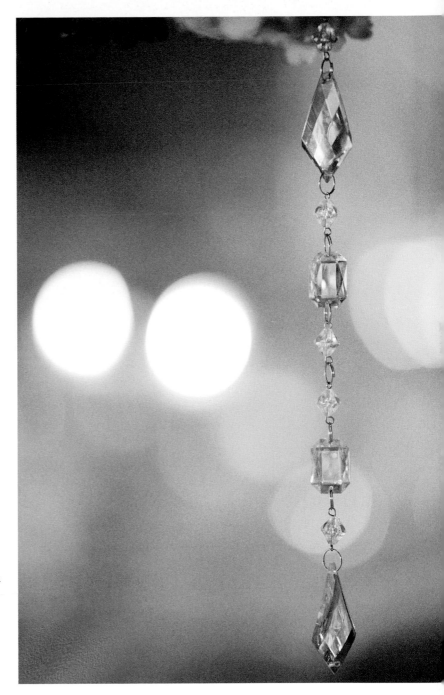

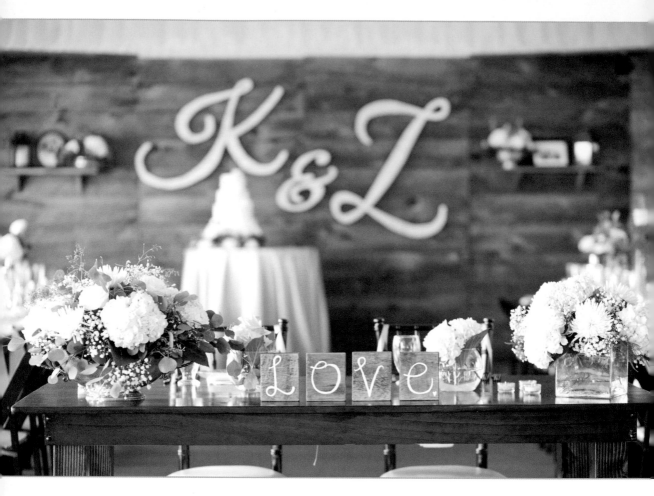

A Tight Shot *(above)*

In addition to shooting the full room, getting a tighter shot of the carefully selected table details is a must! I loved how the word "love" was spelled out in block letters.

There is a great sense of depth in this image—from the table-top display in the foreground to the cake and couple's initials in the background. Still, the overall look is cohesive. I shot with a wide aperture to keep the focus on my intended subject while allowing the more distant details to help to inform the viewer of the theme and overall aesthetic of the wedding day.

Brimming with Personality *(following page)*

Signs are a nice personal touch that require documenting, especially when the bride's and groom's personalities shine through! When I photographed this sign, I didn't want to show the bar and all of the drinks in the composition. I felt that doing so would make the image too busy and would detract from the sign detail. By turning the sign and placing it near a neighboring floral arrangement, I was able to achieve a clean shot that focused on the cute detail!

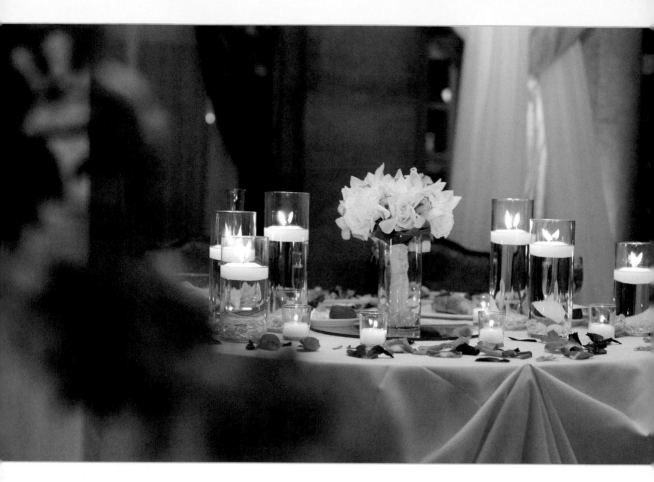

An Opulent Setting *(above)*

This reception table was surrounded by pipe and drape and flowers. I wanted to include the items in the frame, but I had in mind an image that was more artful than straightforward. To accomplish this, I shot from a low angle while positioned slightly off to the side. I used a wide aperture to isolate and highlight the table adornments. The shallow depth of field the f/stop produced provided an impressionistic sort of view of the other elements in the room.

I photographed this scene with a 50mm f/1.4 lens. The exposure was f/2.5, $^1/_{32}$ second, and ISO 320.

Simplify *(following page)*

Sometimes I find that the floral arrangements are so grand that my eye doesn't know where to look first! There is a great deal of detail involved in the display, and I want to highlight the individual elements that make the arrangement so magnificent. By downplaying or eliminating the surrounding environment, the eye can properly focus on the individual flowers that make up the lovely centerpiece, and you can make sure that it receives the attention—and admiration—it deserves.

The Guest's Perspective *(top)*

To create an interesting reception table image, stand next to a neighboring table. If you position yourself slightly off to the side of the centerpiece, you will be presented with a view from a guest's perspective. When shooting this way, use a shallow depth of field so that the viewer's eye isn't distracted from the foreground object.

Candlelight *(bottom)*

Shooting in a candle-lit venue can at times be challenging. You want to capture the dimness of the room, yet you want the exposure to be bright enough to ensure the other details are visible. By setting your flash to $\frac{1}{16}$ or $\frac{1}{32}$, you can achieve a well-balanced exposure in which the candles aren't blown out and the details are still highlighted.

Bouncing Flash *(following page)*

It can be challenging to highlight a centerpiece without losing detail in the surrounding uplight. In this case, I used the white bounce card on my flash to create a well-lit centerpiece that did not get lost in the colorful uplighting.

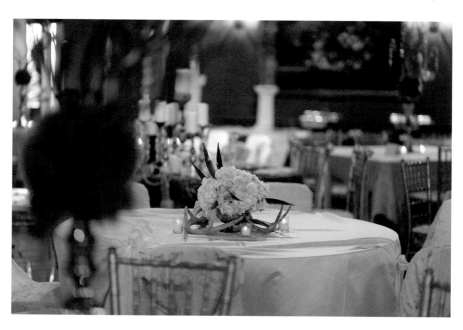

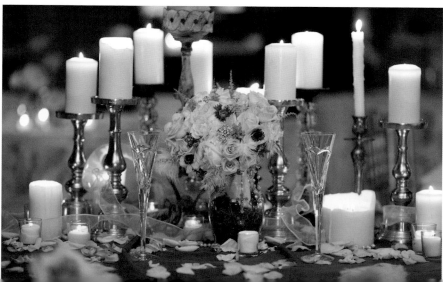

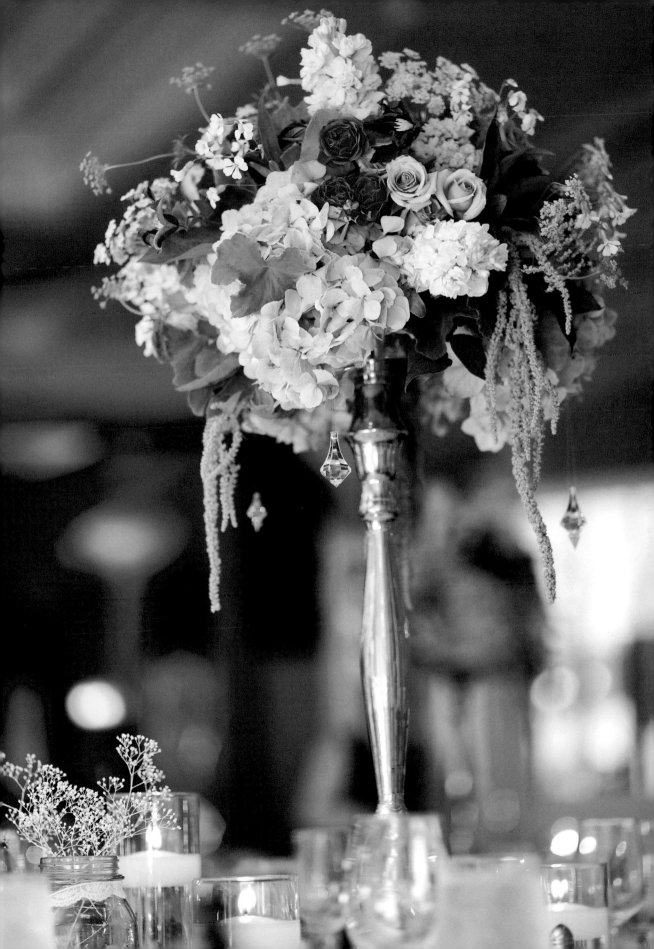

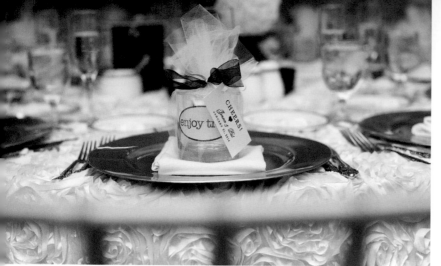

The Ideal Perspective (top)

The guests at this wedding were presented with a glass favor, which was positioned at each place setting. Because of the typography on the glass and the stylized tag, I knew that shooting from a low angle would be ideal.

When you are photographing details that feature type, you want to make sure that the viewers will be able to read clearly what is written; otherwise, you may leave people guessing about the meaning behind the detail.

Shooting Through Glass (bottom)

Don't be afraid to shoot through objects. For example, tables are often crowded with wine glasses and all of the elements that go into making a set table complete. By shooting with a low f/stop you create a feeling of depth and showcase the environment without the image appearing overcrowded. Glassware is a perfect element to shoot through because it's clear and you can then focus on the object you wish to highlight in the image.

Tall Centerpieces *(top)*

When photographing tall centerpieces, shoot from a low angle using a low f/stop. This will help fill the frame with the centerpiece and allow everything else in the image to fall softly out of focus.

For this image, I included the top of a gold Chiavari chair in the frame to create a soft, blurred foreground. By shooting wide open at f/2.2, I was able to bring the viewer's eye to the centerpiece without distractions from the architecture of the grand ballroom.

Service in Motion *(bottom)*

Capturing the movement of food from the kitchen to the table is an interesting way to document the service on the wedding day. These signature drinks were perfectly placed on the tray. Capturing them at a slight angle showed the movement of the waiter.

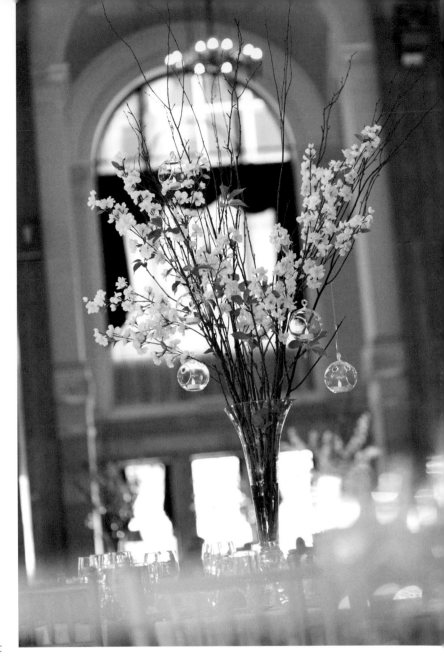

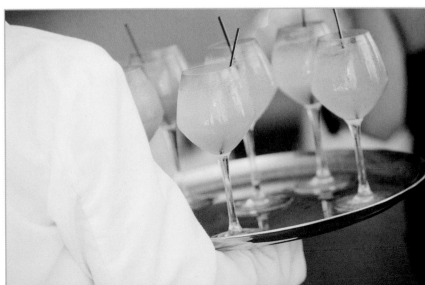

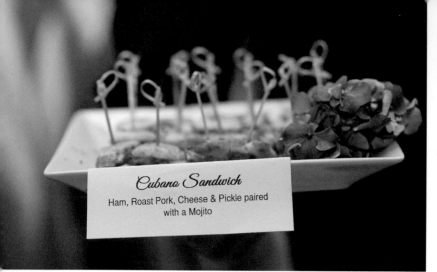

Cubano Sandwich

Ham, Roast Pork, Cheese & Pickle paired
with a Mojito

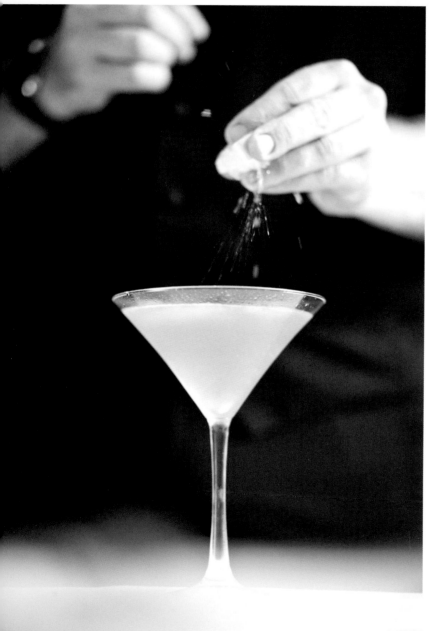

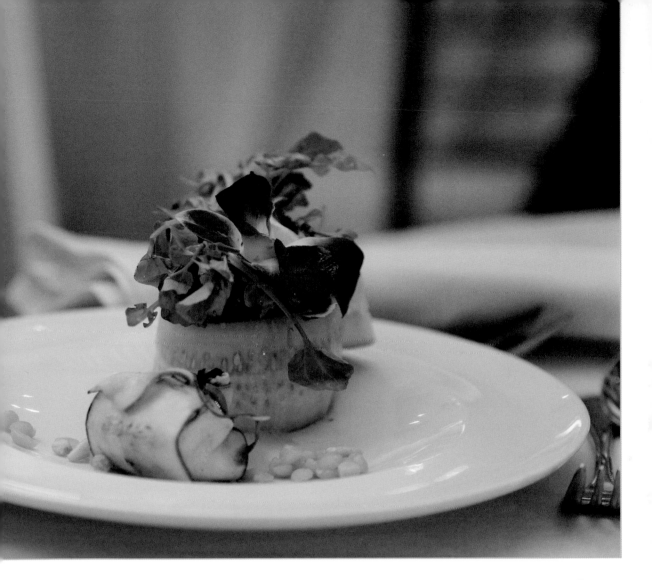

Timing Is Everything (*previous page, top*)

When passed hors d'oeuvres are on the menu, station yourself near the kitchen door so that you can ask one of the staff members to let you capture a photo while the dish is full. Shooting at a low f/stop will allow you to focus on the presentation of the food.

Signature Drinks (*previous page, bottom*)

Signature drinks are becoming more and more popular at weddings. A great way to show them off is to photograph them being made.

This shot worked well because the waiter was wearing a black shirt, which allowed for the mist of the lemon to show. I shot with a wide aperture to produce a shallow depth of field. As a result, the image has a softness to it that is very pleasing to the eye.

Presentation (*above*)

Food presentation enhances the elegant feel of the wedding day. It's another "wow" factor for guests. If you see food with an eye-catching presentation being served, try to capture it before the guests begin to eat! Look for a table where a guest is not seated—perhaps they went to get a drink or to talk with other guests.

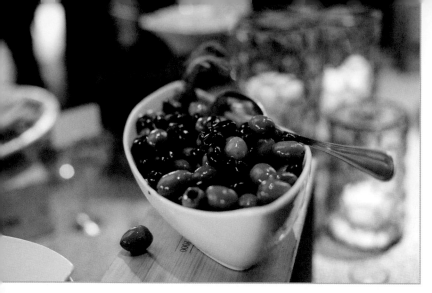

Cocktail Hour *(top)*

It is not common that the bride and groom will be able to attend their cocktail hour. Having spent a great deal of time selecting the perfect menu for their guests, they will appreciate your taking the opportunity to feature some of the elements in your wedding day photo story. Be sure that any spoons are tucked in to create a clean look.

Creating Art *(bottom)*

I love to capture a food image from an uncommon perspective. The bride and groom and even the guests are often busy engaging in conversation while dining and may not take the time to fully appreciate the work of art the chef has created.

In this image, I wanted to show the food as more than a still life. By incorporating an action, I was able to bring life to the image.

Plated Appetizers
(following page)

People don't enjoy having a camera in front of their face while they eat, so capture plated appetizers before the guests sit down. By including the table setting in the image, you can present a more complete photo story.

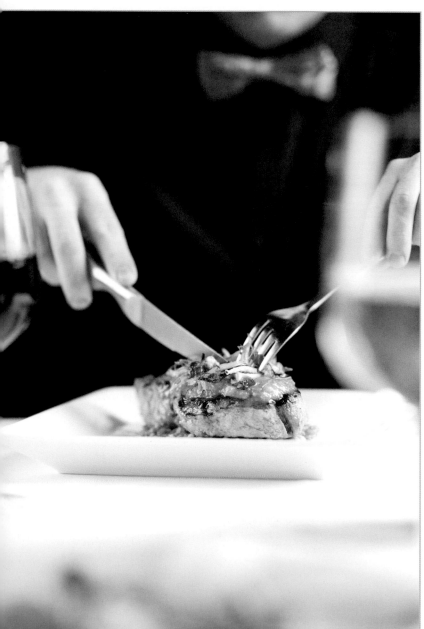

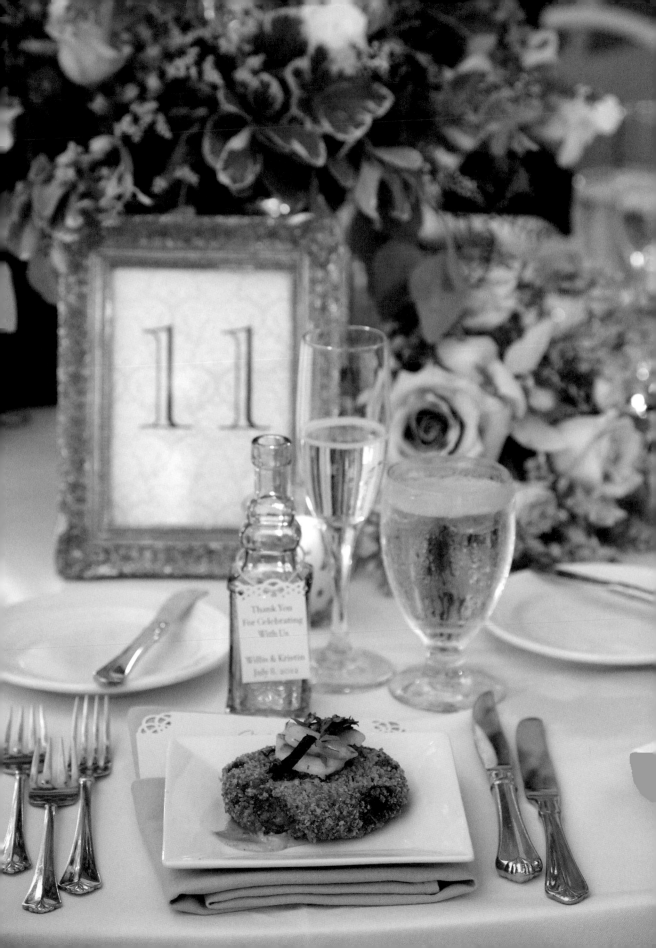

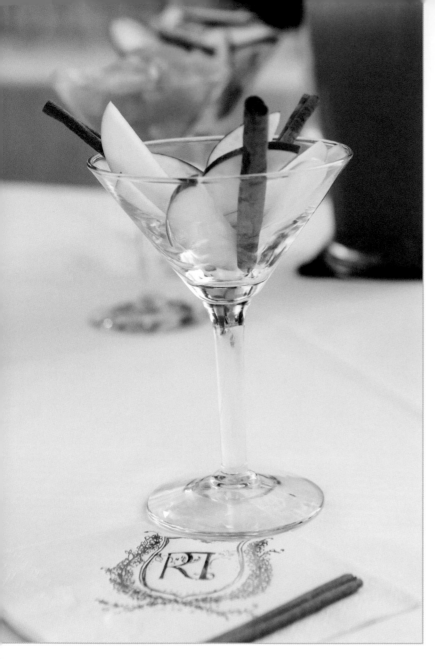

All the Trimmings *(top)*

The bride and groom who hosted this fall wedding planned to have cider offered to their guests. Next to the bar, there were some garnishes that could be added to the drink. I love the simplicity of the sliced apple with the cinnamon sticks. I placed the cocktail glass on top of the couple's custom napkin to capture an image that beautifully suited the autumn theme.

Setting the Mood *(bottom)*

Low, soft light and a shallow depth of field lent a beautiful ambiance to this rustic spread.

I photographed the food with my 24–105mm lens set at a focal length of 84mm. The exposure was f/4, $1/40$ second, and ISO 1250.

Passed Hors d'Oeuvres *(following page, top and bottom)*

Interesting angles and creative cropping can add impact to your photographs of plated hors d'oeuvres and will beautifully document the talents of the chef.

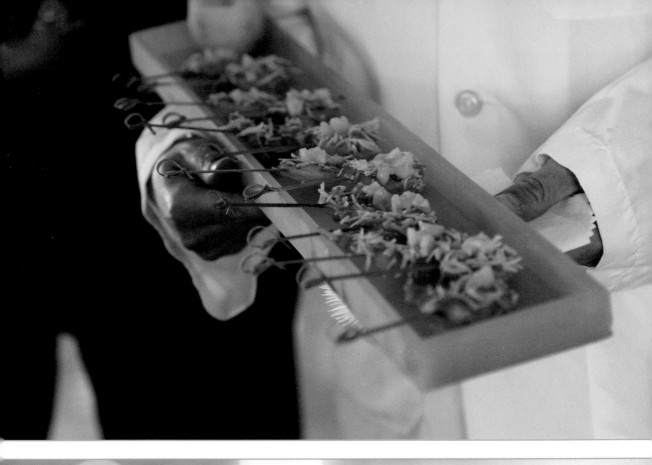
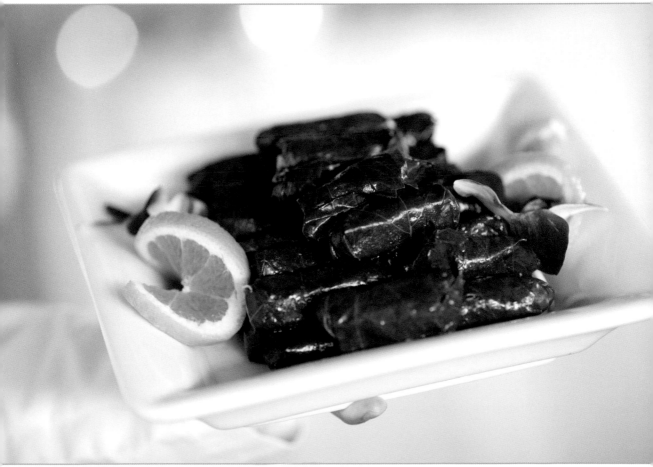

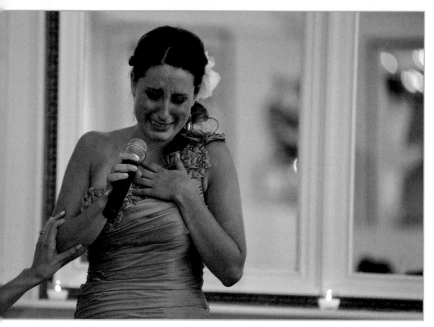

Guest Candids *(top)*

Capturing reaction shots of guests is key to telling the story of the wedding day. Using a long lens, like Canon's 135mm, you can document authentic reactions without the guests knowing. Composing shots like these with a shallow depth of field will help the viewer's eye go directly to the subject.

A Meaningful Toast *(bottom)*

Toasts tend to bring out a lot of emotion, both in those who have prepared a meaningful speech and in the bride and groom.

The head table—with all of its embellishments and the wedding party—can appear busy. Try to center the focus of the image on the emotions by cropping in close.

As They Mingle

(following page)

As the bride and groom mingle with their guests, stay close to get some great reaction shots. This helps tell the story of the day and serves as a reminder of how many people support and love them. This image was shot with my 85mm; it is a great lens for capturing moments like this.

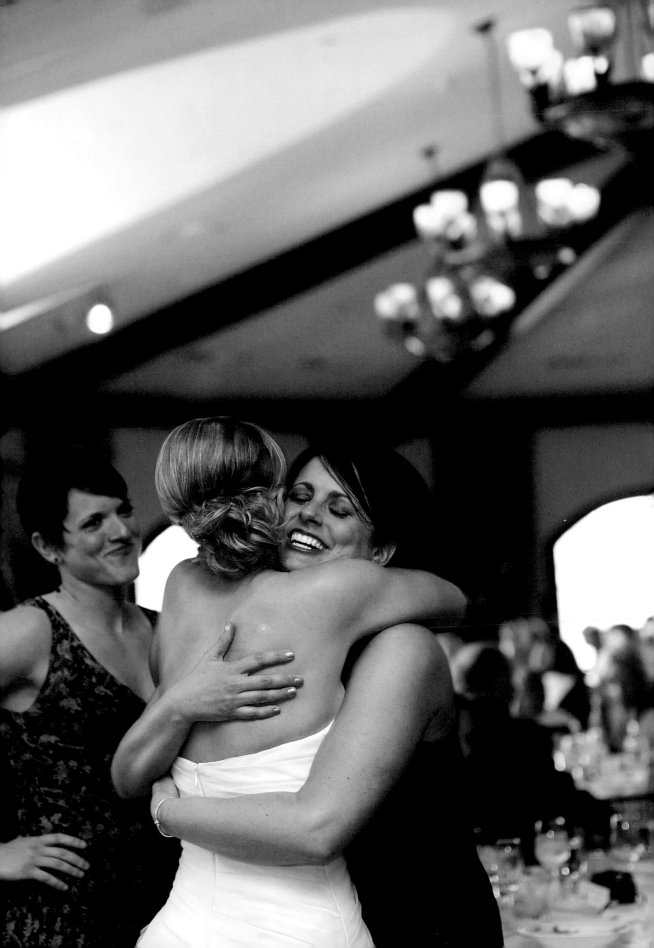

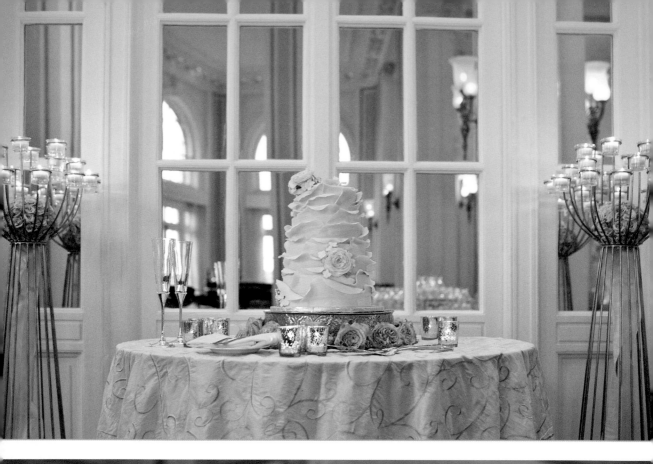

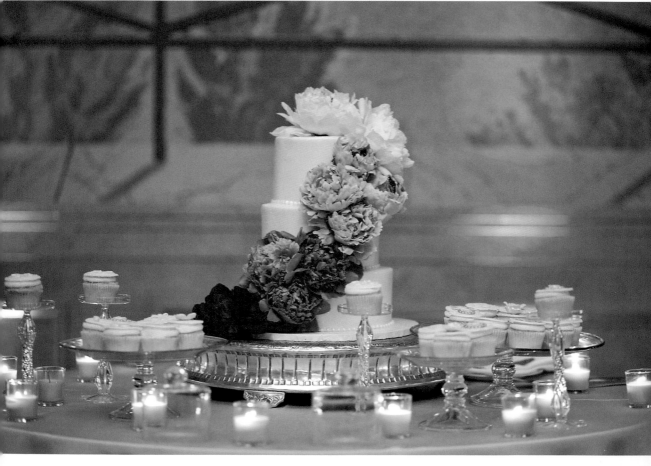

Mirrors *(previous page, top)*

Shooting into a mirror can be tricky. When shooting, bounce your flash to add a touch of soft light on the subject. Also, position yourself at a low angle so that you do not appear in the mirror!

An Elegant Cake Table

(previous page, bottom)

Here is a perfectly styled cake table. I loved how the cupcakes were positioned, and there was a perfect amount to complement the amazing cake.

The pink uplighting on either side of the cake draws your eye to the center of the frame. In a situation like this, it's a good idea to use the white bounce card on your flash unit to help balance the tones in the photograph and prevent the image from becoming too warm from ambient light.

Cupcake Detail *(right)*

This cupcake was decorated with edible gold glitter! One doesn't see that often! I loved how that element, along with the pink sequined tablecloth, added up to a beautifully girlie presentation.

I grabbed one of the custom napkins to help tell the story. By shooting from above, I was able to document all of the important elements—the gold glitter, the napkin detail, and the subtle sparkle in the table linen.

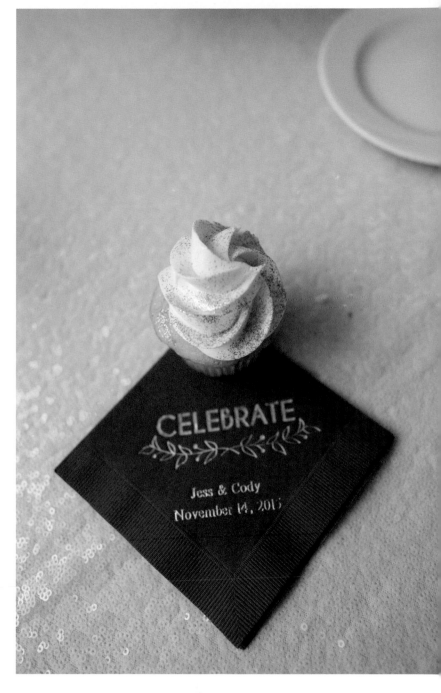

Isn't It Sweet? *(previous page)*

These cupcakes were stacked and decorated with tiny blue sugar beads and purple orchids. The surrounding walls were white and provided a nice clean backdrop. By shooting at f/2.0, I was able to focus on the frosting and flower in front, while creating a hazy, eye-catching depth of field.

The Groom's Cake *(below)*

This cake was a surprise for the groom. Because he owns a landscaping business, the bride had a custom topper made that depicted their family.

By shooting from the side, I was able to capture the custom piece straight on. As the cake was positioned in front of a mirror, shooting from that perspective also allowed me to get the shot, without my reflection appearing in the frame.

I photographed the cake with my 85mm f/1.8 lens. The exposure was f/2.8, $\frac{1}{40}$ second, and ISO 1000. I added fill flash to ensure a proper exposure, with detail in the highlights and shadows.

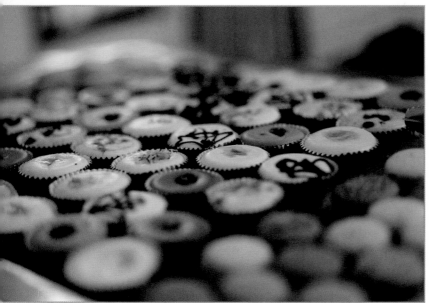

The Dessert Table *(top)*

The dessert station is such a fun thing to shoot! Most of the time, the desserts featured are tiny. In an effort to make sure they don't get lost in a big setting, move in close and focus on some of the individual offerings.

My favorite lens to capture desserts with is the 85mm.

Helpful Hint *(bottom)*

Shooting small desserts from a low angle and with a wide aperture allows you to create a sense of dimension in the photograph.

A Botanical Touch

(following page)

This cake had such a lovely floral topper! I typically like to photograph the cake from a low angle, but in this case I thought that photographing from a slightly more elevated perspective would allow me to better highlight the romantic floral detail.

I used my Canon 600 RT flash to add a touch of fill light on the subject without overpowering the soft light from the votives.

INDEX

Photograph Couples

Tiffany Wayne provides a step-by-step guide to creating the emotionally charged images that couples truly love. *$27.95 list, 7.5x10, 128p, 180 color images, order no. 2031.*

How to Photograph Weddings

Industry leaders share the lighting, posing, design, and business techniques that have made them successful. *$27.95 list, 7.5x10, 128p, 240 color images, order no. 2035.*

The Beckstead Wedding

Industry fave David Beckstead provides stunning images and targeted tips to show you how to create images that move clients and viewers. *$27.95 list, 7.5x10, 128p, 200 color images, order no. 2045.*

Portrait Mastery in Black & White

Tim Kelly's evocative portraits are a hit with clients and photographers alike. Learn his classic style in this book. *$27.95 list, 7.5x10, 128p, 200 images, order no. 2046.*

The World's Top Wedding Photographers

Ten of the world's top shooters talk with Bill Hurter about the secrets of their creative and professional success. *$27.95 list, 7.5x10, 128p, 240 images, order no. 2047.*

Epic Weddings

Dan Doke shows you how he uses lighting, posing, composition, and creative scene selection to create truly jaw-dropping wedding images. *$37.95 list, 7x10, 128p, 180 color images, order no. 2061.*

Stylish Weddings

Kevin Jairaj shows you how to create dramatic wedding images in any setting—shots that look like they were ripped from the pages of a magazine! *$34.95 list, 7x10, 128p, 180 color images, index, order no. 2073.*

Dream Weddings

Neal Urban shows you how to capture more powerful and dramatic images at every phase of the wedding photography process. *$27.95 list, 7.5x10, 128p, 190 color images, order no. 1996.*

Sikh Weddings

Gurm Sohal is your expert guide to photographing this growing sector of the wedding market. With these skills, you'll shoot with confidence! *$37.95 list, 7x10, 128p, 180 color images, index, order no. 2093.*

Wedding Photography Kickstart

Pete and Liliana Wright help you shift your wedding photo business into high gear and achieve unlimited success! *$37.95 list, 7x10, 128p, 180 color images, index, order no. 2096.*